A Lesser Mortal

A Lesser Mortal

*The Unexpected Life of
Sarah B. Cochran*

KIMBERLY HESS

ISBN: 978-1-953865-14-4 (Paperback)
ISBN: 978-1-953865-15-1 (eBook)
Library of Congress Control Number: 2021902094
Books Fluent
3014 Dauphine Street
New Orleans, LA
70117

For Mark and Olivia

Contents

PREFACE XI

PROLOGUE 3

PART I
A Series of Economically Dependent Relationships

1 Farmer's Daughter — 13

2 Entrepreneur's Maid — 26

3 Magnate's Wife — 37

PART II
Full Charge, Care, and Control

4 Fortysomething Widow — 63

5 Coal Queen — 72

6 Educational Philanthropist — 97

7 Trustee — 120

8 Builder — 130

9 Activist and Influencer — 151

CONTENTS

EPILOGUE: THE MINISTRY OF WOMAN
174

APPENDIX 187

ACKNOWLEDGMENTS 191

BIBLIOGRAPHY 199

DISCUSSION QUESTIONS 227

"The past is not dead, it is living in us, and will be alive in the future which we are now helping to make."

William Morris

Preface

I grew up with the power of women's experiences in the stories I heard about female ancestors and relatives. Whether they were politically active, ahead of their time, or overcoming enormous obstacles, each one's story helped me to understand what I could do. One of those relatives was Sarah B. Cochran. The only reason I knew about her was that we were related, so when I regularly visited family in southwestern Pennsylvania, I saw artifacts from her life, like her mansion and church, and knew how her life had affected my own. In that part of the country, it seemed that everybody knew something about her.

Admittedly, the information that I knew about Sarah was sparse: She was from a poor farming family and married a coal and coke magnate whose father had pioneered the Connellsville coke industry. The family was highly respected as paternal capitalists who stayed local and invested in their community.

When her husband and son died around 1900, she took over the business and traveled abroad, built churches, and became a college trustee. Her mansion and one of her church projects were added to the National Register of Historic Places when I was a little girl, and that church remained connected to my family in varying degrees for five generations. Sarah's mother was my third great-grandfather's sister, and years later my family was still proud that Sarah put my great-grandmother, Henrietta Sproat Stillwagon, through college. Loved for being unassuming despite the privilege she acquired, Sarah seemed to be the sort of person who chased meaning rather than audiences and whose humility allowed her to interact with anyone. I developed an idea of Sarah and sometimes related a part of myself to her.

In some ways Sarah was in the background when I was the only girl in my first-grade gifted-and-talented reading and math classes, and certain places in New York have always made me think of her. Her philanthropy, house, and travel helped me grow up with an idea of what successful women could do. She stayed with me in my business career and personal life, as it became clear that if people hadn't grown up with stories about women like her, their visions of and for women could be limited. As an active alumna of my undergraduate alma mater, I would remember Sarah and my great-grandmother, Henrietta, when

considering the returns on investments in women's education. My experience as a trustee of the Alice Paul Institute gave me a perspective on Sarah's era of suffragists and forced me to consider women relative to both the built environment and paths to enter the historical narrative. Then, while organizing women's history programming on the board of a corporate employee resource group, I saw how excited people outside the field of history were to learn about the incredible things women have done.

When I was at home to raise my daughter, I began to consider the value of making Sarah's story more widely known with the experience and perspective I had. I began to document it with a larger audience in mind. I had already written her Wikipedia entry, then added a museum guest blog post, a National Women's History Museum biography, and made a StoryCorps recording. Those projects pushed me to spend two more years researching more about her life and then supplement my findings with genealogical research I'd been doing over the course of thirty-six years. Beyond learning more details of her life, I also discovered a woman who became highly productive in the periods we know as midlife and senior years. As a middle-aged woman myself, I thought for the first time about the opportunities and challenges age might have presented to Sarah. I also learned that the woman I'd grown up associating with a church was

also a suffrage activist and fraternity-house name-sake. I had to learn more

But, despite her unique position as a woman who owned coal and coke companies in Pennsylvania's early twentieth-century boom years, it's hard to find Sarah if you don't already know she's there. On the rare occasions when her name is mentioned, it is usually as a coal magnate's widow, not as an accomplished woman in her own right. Sarah falls through the cracks when writings about the coal and coke region focus on miners' wives or rely on oral histories from employees of the H.C. Frick Coke Company, one of Sarah's competitors. After all, coal and coke companies weren't in the business of writing biographies. Even her occupational information, sometimes portrayed as a blank space or the word "employer" on the U.S. Census, wouldn't suggest any of the responsibilities or influence that she actually had.

Next to names like Carnegie and Frick, the historical narrative treated Sarah as one of the "lesser mortals" of her place and time. That is, she remained largely unknown despite her very important accomplishments. This makes her story important to tell for a few different reasons. First, the fact that a woman has remained invisible after her businesses competed with Frick's and her philanthropy sometimes rivaled Carnegie's is a good reason to tell her story. I hope this will inspire others to tell stories of the "lesser mortals"

who affected their own communities. Second, despite Sarah's very specific interests, there is a universality to her story because it is about using the power we already have, living with purpose, being resilient, championing others, and publicly owning our identities. Her experiences in business and philanthropy even raise questions about how to effect change when one reaches the limits of a broken system.

Because I am not an academic, this work is not meant to be scholarly, nor is it made possible with research assistants, grants, or office hours. Because there was no writing on Sarah at the time of my research, I had the luxury of deciding what parts of her life fascinated me the most, as well as the challenge of identifying what information was actually available. For example, her businesses were said to have covered parts of Pennsylvania, West Virginia, Virginia, and Tennessee, but by focusing on mine reports from Pennsylvania, I was able to research the industry and her activity in a little more depth. A transcription of one letter from Sarah was available (see Appendix), and it is unknown whether a diary or other letters could be out there somewhere.

I've set parameters to try to introduce a meaningful discussion of Sarah's life that is framed by my own expertise. Beyond that, there are a few specific research limitations to point out. It is difficult to identify all of the company towns or housing

owned by Cochran companies. The Washington Coal and Coke Company established and owned the town of Star Junction, Pennsylvania, and I found late twentieth-century research indicating that it was established in the 1890s for whites only. I have not been able to find what Sarah might have known or thought about the decision or whether she tried to do anything about it when the company came under her ownership. This subject is important and would ideally be covered by someone with specialized knowledge of the culture of late nineteenth-century company towns and the ability to cull data for a cross-section of coal and coke companies owned by the Cochrans and other operators. Two other areas out of scope were the details of her travel abroad and the decorative arts and architecture associated with her building projects. Her travels could be very interesting to document, particularly to investigate the extent to which any were related to the Methodist Church's presence overseas versus her own curiosity.

I will explain my connection to Sarah and western Pennsylvania in the prologue. After that, the book is arranged in two parts. The first covers Sarah's early life and adulthood until the death of her son, a span from 1857 to 1901. Because she would have been expected to be dependent on her father and husband during that period, chapters are titled according to those relationships. The second part is arranged

thematically by the actions she took as a widow on her own between 1901 and her death in 1936.

This book is intended to be an introduction to her life, not a detailed or definitive biography. Sometimes it raises questions rather than answers them, and my research even left me with questions that I wish I could ask Sarah herself. I've included information about the era's coal and coke industries to explain the source of Sarah's wealth and how she navigated those industries, not to retrospectively criticize or praise them. Like any other human being, Sarah's life was complex and not confined to one area of interest. In one way or another, her life could probably spawn multiple dissertations, oral histories, documentaries, or coffee table books.

Although she grew up probably just expecting to have a small life in rural farmland, she ended up engaging in business and influencing the culture of coal and coke towns in a particular place and time. Her activities could be studied in terms of Appalachian studies, labor relations, Gilded Age capitalism, socioeconomic divisions, feminism and sexism, racism, nativism, Methodism, women's history, fine and decorative arts, architecture, philanthropy, and men's and women's education.

Now I have a story to tell you about a remarkable woman from a part of the world where my family lived for almost 200 years.

New Jersey, 2020

A Lesser Mortal

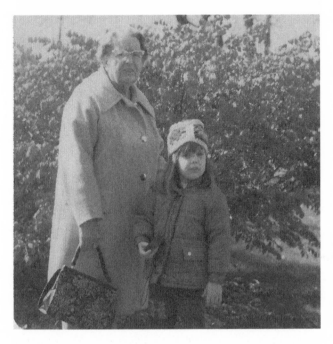

The author with her great-grandmother, Henrietta Sproat
Stillwagon, in October 1977. Image from the author's
collection.

Prologue

I n March of 1974, I was in a car speeding west across the Pennsylvania Turnpike to get my religion, partly because of decisions that had been made from 1800 to 1969. I can't remember that first trip from New Jersey to southwestern Pennsylvania, but I know that I was two months old, and my parents had packed me into our car to drive to Fayette County. It was where they both had grown up, an hour south of Pittsburgh, and their families were still there, which meant that my father's family church was there. My first literal journey took place for my baptism, which was meant to mark the start of a spiritual one. Coincidentally it also marked the first of many six-hour car trips that we took almost monthly and for major holidays and weddings.

My family began living in southwestern Pennsylvania soon after the American Revolution. But in the late twentieth century, as my parents and

I drove through Somerset County's mountains, I sometimes wondered what motivated people to pack their families and worldly possessions into wagons and cross three hundred miles of forests and mountains so many years ago. My ancestors were a microcosm of the era's wave of white settlers who moved west at that time. They were German immigrants who had served in Washington's army and moved west for land and Swiss Mennonites from Lancaster and Bucks Counties seeking better farming opportunities. Virginians had been given hundreds of acres of land within Virginia but navigated to Fayette County, believing they were still in Virginia. The occasional Quakers and people of English descent relocated from New Jersey, sometimes for unknown reasons. Some of these people were men who had served in the American army or local militias during the Revolution. One of those was Thomas Herbert, whose grandchildren included my third great-grandfather, Henry Herbert, and Henry's sister, Sarah Herbert, who was Sarah Cochran's mother.

There has been speculation as to how, when, and why Thomas Herbert's ancestors arrived in New Jersey; while there are interesting legends about early connections to English earls, there is real documentation connecting Thomas to the American Revolution and his move west. Apparently, Thomas and two of his brothers served in the American

army during the war. Thomas' pension application described about twelve months of service on the Jersey shore near modern Manasquan between 1776 and 1778. New Jersey was the location for a number of the Revolution's battles, and Monmouth County was hardly peaceful. A concern along the coast was British landings, and Thomas' safety wouldn't have been guaranteed on scouting missions. For example, around the time of Thomas' service, a young German immigrant named Peter Stillwagon was serving nearby in Washington's army. During an expedition in Eatontown to warn of a British and Tory landing,[1] he was captured by the Tories and marched to the Sugar House Prison in New York City. While he was at war, his wife, Elizabeth, and their toddler children saw their home plundered and burned.[2] Thomas Herbert, on the other hand, didn't describe capture or any severe hardships during his service.[3]

After the war, Thomas and one of his brothers moved to Fayette County, Pennsylvania, where they had families and apparently lost contact with their Monmouth County relatives. Based on extant and

1 Deposition of William Hurley, August 13, 1833, Revolutionary War widow's pension application no. W25811, Fold3.com.

2 Deposition of Elizabeth Stillwagon, May 6, 1846, Revolutionary War widow's pension application no. W3197, Fold3.com.

3 Thomas Herbert, Revolutionary War pension application no. S18443, Fold3.com.

absent records, Thomas' wife, Alice Hill Herbert, might have predeceased Thomas, who moved farther west to Blooming Grove Township in Richland County, Ohio, later in life. It's possible that he lived there with an adult son named Samuel, but because he didn't leave a will in Ohio or Pennsylvania, Thomas' later life and relationships are a matter of conjecture based on early census and family records. Alice left even less of a paper trail, but she was known to have been from New Jersey like Thomas.

One of Thomas and Alice Herbert's sons, named Richard Herbert, lived out his life as a farmer in Fayette County with his wife, Margaret Shoup/ Shoub (evidence of the spelling of this name differs), and their children. Some of these children were Thomas, Richard, my third great-grandfather Henry, and Sarah B. Cochran's mother, also named Sarah. According to the 1850 U.S. Census for Dunbar Township, both Henry and Richard were farmers like their father.[4] Even the year before her death, Sarah B. Cochran still recalled that her mother "had great influence of her brothers" (see Appendix). Religion seemed to be important in this family; Henry Herbert's Methodist books from the 1870s would stay intact and in the family for over a hundred years.

4 1850 United States Census, Dunbar Township, Fayette County, Pennsylvania, digital image *s.v.* "Richard Herbert," FamilySearch.org.

In the years that followed, my ancestors intermarried with people of similar backgrounds and with immigrants who arrived in western Pennsylvania from the United Kingdom and nineteenth-century German kingdoms and principalities. In my lineage, connections to places like New Jersey vanished from the collective memory, and no one left western Pennsylvania until 1969. That year my parents got married and moved to New Jersey, where my dad had just become a professor, unaware that some of our family had been there 200 years earlier.

In New Jersey, we lived in Pennington and then Titusville, which were convenient to New York, Philadelphia, and the eighteenth century. Stories about Hessian soldiers still circulated in Pennington; across the river from Titusville, Washington's Delaware River crossing was reenacted annually with replica Durham boats that were set in the water so regularly that they seemed to help mark the holiday season. Even my elementary school was named for a colonial-era tavern that had been on Washington's marching route. Growing up in that area was firsthand experience in the practical art of keeping history alive.

We drove to Fayette County almost monthly and for major holidays to see family. The three-hundred-mile car trips that took us there passed through Pennsylvania Dutch Country and beyond Three Mile

Island's nuclear reactors before we drove through four tunnels: Allegheny, Blue, Kittatinny, and Tuscarora. The road swung up and around mountains that the world wouldn't notice until Flight 93 crashed there on September 11, 2001. Heavy winter storms in that stretch of the trip usually produced trees that looked like they had been strung with threads of elegant glass beads, a counterpoint to the runaway truck ramps on small and steep mountain roads that were unknown where I lived. Farther west, small towns that had been prosperous during the coal era still kept references to Frick, Carnegie, and Vanderbilt in the names of hospitals, libraries, and towns themselves. It was clear from the architecture that Gilded Age money and industry had been there, but as we watched the occasional house slowly shift as a victim of mine subsidence, the less luxurious side of mining's impact was visible, too. Coal still loomed quietly in a way that differed from references I associated with New York's Gilded Age institutions.

After a long car trip, we would arrive in the area where young George Washington had provoked European and Native American powers to clash in the forests during the French and Indian War. It is also where the Whiskey Rebellion tested the efficacy of the U.S. Constitution and where modern tourists find Fallingwater and whitewater rafting. But this was also where artifacts reinforced my personal connections

and inspired stories when I visited. For example, on a road near Broad Ford, the Cochran Cemetery, always stoic on its hill, provided the reassurance that some of my great-grandparents were there with their relatives. In my grandmother's house, decorative arts and architectural details suggested the wealth of another era, or "Coal Baron Chic," as a friend from Fox Chapel, Pennsylvania, called it. "There was a millionaire on every corner," people would say when talking about the town of Dawson in the early twentieth century. My mother's family still recalled my great-great-grandmother's pair of diamond earrings with stones so large that they were reset into two engagement rings, and the women's group meetings she arranged with her cousin serving in the U.S. Congress. The wealth produced by coal and its lucrative byproduct, coke, at the turn of the twentieth century was the rising tide that lifted all boats there. Even a great-uncle's high school ring, curiously embossed with images of coke ovens, suggested that. Instead of a marauder or ferocious animal as a mascot, his school was represented by the coker, the man who the tended the coke ovens that brought prosperity.

On my first visit there, I was going to church. Specifically, a Methodist church that my great-great-grandmother's cousin, Sarah B. Cochran, had built forty-seven years earlier and named for her husband. Just as I would take for granted that a colonial tavern

could be the namesake of an elementary school, I would grow up taking for granted that a church could be named for a coal baron. This one was where my parents were married and where my paternal grandparents were trustees and choir members. Two great-grandparents had married in the parsonage, and even my great-great-grandmother seemed to have been associated with the previous structure. Without intending it, my baptism was a first step in assuming that women own businesses, take leadership roles in religion, invest in their communities, and build important buildings. I was getting my religion in more ways than one.

PART I

A Series of
Economically
Dependent
Relationships

Farmer's Daughter

P resumably early in her life, Richard and Margaret Herbert's daughter, Sarah, married James F. Moore, a man who appears to have been almost fifteen years older than she was. His father was said to have migrated from Massachusetts to western Pennsylvania, where he married and had seven children with Susanna Swink.

According to local histories, James and Sarah Moore had nine children; one was a daughter, Sarah Boyd Moore, who was born on April 22, 1857. Reflecting on her childhood home, Sarah described her parents as having a "kindly, loving influence" and a "Christian atmosphere" in their home (see Appendix). She wrote that she "was realizing more and more as the years passed what a part they had played in her own character-building, and in her own home and the privilege of motherhood which later came to her."

The family lived in a log house in Fayette County, which may sound primitive for someone who was still alive in the 1930s, when she wrote the letter just cited. However, in some ways Sarah Cochran's life began in a very different era, very long ago. She was born seven years after the Fugitive Slave Act was passed. Andrew Carnegie was starting to work his way up the Pennsylvania Railroad's corporate ladder, and Pittsburgh was still considered a western city in America. Edith Wharton, the novelist of the Gilded Age, wouldn't be born for another five years, and the frontier icon Laura Ingalls Wilder wouldn't be born for another ten.

The Civil War Era

Just before Sarah's fourth birthday, Fort Sumter was attacked. When the Civil War broke out, its impact was undoubtedly close to home as Fayette County joined Pennsylvania and other Northern states in raising Union troops. While it is not known how many of the Herbert brothers served in the military, it is clear that Sarah's uncle, Thomas Herbert, was a member of Pennsylvania's 168th Regiment. Later in life Sarah Cochran could still recall her mother reading battlefield letters from one of her brothers. "In my tent," he wrote, "we are holding a service of prayer while in the next tent they are playing cards. If I fail here, it is only to rise higher" (see

Appendix). If Thomas wrote that letter, his service of prayer might have been related to his denomination's, the United Brethren's, beliefs, or it might have been immediately related to health conditions. According to his 1863 obituary,[5] Thomas "took the intermitting fever while at Washington, North Carolina, about the 20th of June. He got home on the 28th of July, took the Typhoid fever and died on the twelfth day after." He left behind his widow, Rose Ann Greene Herbert, and six children.

One can only imagine how Sarah might have reacted to this loss or to watching Rose Ann and her children manage after the war, apparently without remarriage. Through widows' pension records and U.S. Census records, Rose Ann's life was documented on a very basic level until her death in 1915. While some women from this socioeconomic background didn't have detailed obituaries, Rose Ann's described her as "one of the oldest women of Fayette County and widely known throughout the Connellsville district ... recognized as an authority on events which made history for this section of the country and often recalled events leading to the Civil War."[6] Those words suggest that value was placed on this woman's ninety-seven years and wisdom, and

5 "Died, Herbert," *Genius of Liberty* (Uniontown, PA), August 20, 1863, 3.

6 "Dawson Woman, Aged 97, Dies," *Morning Herald* (Uniontown, PA), May 17, 1915, 1.

that Rose Ann's widowhood didn't keep her from engaging with the community.

Around the Civil War era, Fayette County was very rural, and the U.S. Nonpopulation Census records offer a snapshot of the farming ventures, crops, and animals that populated the landscape during Sarah's early life. Farms could be as small as ten acres or as large as Stewart Strickler's 480 improved acres and 150 acres of woodland.[7] For example, Thomas Sproat owned 146 acres of improved land valued at $14,500 in Tyrone Township.[8] Like other farmers in the area, he owned horses, pigs, and cattle, and while some farmers also raised sheep, Sproat and many others did not. During a year, local crops were concentrated in winter wheat, corn, and oats with Sproat's farm turning out 150 bushels of Irish potatoes, $75 worth of orchard products, one thousand pounds of butter, and fourteen tons of hay. A few local farmers produced fourteen to forty gallons of molasses each, and one neighboring farmer owned bees that industriously produced fifty pounds of honey. Nearby in the same township, John Cochran's farm of fifty-four improved acres produced harvests, but

7 1870 United States Nonpopulation Census, Tyrone Township, Fayette County, Pennsylvania, digital image *s.v.* "Stewart Strickler," FamilySearch.org.

8 1870 United States Nonpopulation Census, Tyrone Township, Fayette County, Pennsylvania, digital image s.v. "Thomas Sproat," FamilySearch.org.

the word "coal" was discreetly written where other farms just recorded woodland acreage.[9]

Oral history has always emphasized the poverty that Sarah's immediate family experienced. In 1860, her father was recorded as a forty-nine-year-old cropper on the U.S. Census for Dunbar Township.[10] That occupation suggests that James might not have owned his own farm because proprietors of farms would have been listed as "farmers."[11] Beyond that, a value of $300 was assigned to James' personal estate, with no value listed for owned real estate. A twenty-nine-year-old theological student named John Dixon was listed in the household, perhaps as a boarder welcomed for financial reasons or as a church member or relative who needed support. Ten years later, the 1870 U.S. Census for Tyrone Township indicated that James simply "works on farm."[12] Sarah's mother was forty-two and "keeping house," which probably meant farm work and looking after the children, who now ranged from five years old to

9 1870 United States Nonpopulation Census, Tyrone Township, Fayette County, Pennsylvania, digital image *s.v.* "John Cochran," FamilySearch.org.

10 1860 United States Census, Dunbar Township, Fayette County, Pennsylvania, digital image *s.v.* "James F. Moore," FamilySearch.org.

11 U.S. Census Bureau, *Instructions*, 15.

12 1870 United States Census, Tyrone Township, Fayette County, Pennsylvania, digital image *s.v.* "J.F. Moore," FamilySearch.org. [Transcribed as J. T. Moore in FamilySearch.org]

teens. A teenage son was employed in the coal and coke business, and so were some of the family's male neighbors. These men and boys represented a large labor change since the 1860 census: men and boys who might have become farmers or blacksmiths were working as coal miners. The Connellsville coke industry was in growth mode, and Henry Clay Frick was beginning to build coke ovens a matter of miles away in Broad Ford. At the time it might have seemed incredible—even to Sarah—that a farmer's daughter would become an owner in that industry and be a competitor of Frick's.

Childhood

The Moores seemed to value education for their sons and daughters despite financial hardships. The historian Gerda Lerner has suggested that a female's position in society should be compared to males in her social group and time,[13] so one could compare Sarah's education to that of her brothers. The 1860 U.S. Census[14] showed that Moore children aged six and over attended school, and oral history has suggested that Sarah went so far as sharing a dress with one of her sisters so each would have proper clothing for attending school on alternate days. Her older

13 Lerner, *The Creation of Patriarchy*, 38.

14 1860 United States Census, Dunbar Township, Fayette County, Pennsylvania, digital image *s.v.* "James F. Moore," FamilySearch.org.

brother, James C. Moore, was educated locally in Dunbar schools and then started working as a laborer in the area's coal mines around 1870.[15]

College education seemed to be impossible, presumably for financial reasons, for anyone in the Moore family. Only seven years before Sarah was born, a resolution was presented at the 1850 Ohio Women's Rights Convention claiming that education was actually a woman's natural right. By the time Sarah became a teenager and college-age, women would represent only 21 percent and 32 percent of total undergraduate enrollment in colleges in 1870 and 1880 respectively.[16] The Troy Female Seminary already existed but was quite a distance away. Some of the Seven Sisters schools would be founded during Sarah's early life and adulthood, but those would be unattainable for someone in Sarah's situation. About eighty miles away, the Beaver Female Seminary had been established in 1853 in Beaver, Pennsylvania, but that was probably not financially possible, either. Instead, it would be where Sarah would be a trustee and endow a chair years later.

Like Sarah, the muckraker Ida Tarbell was also born in a log house in 1857, but in northwestern Pennsylvania, where her father saw people moving west in their wagons to the frontier. In the absence

15 Gresham, ed., *Cyclopedia*, 458.

16 Lerner, *The Creation of Feminist Consciousness: From the Middle Ages to Eighteen-Seventy*, 43-44.

of diaries or letters describing Sarah's childhood, a description of Tarbell's might be instructive. In her memoir, *All in the Day's Work,* Tarbell describes a childhood that contrasted with Sarah's. Tarbell's family was financially comfortable and had the money and worldview to encourage a young woman's academic pursuits. They visited Cleveland and had a small library of books, a piano, and a microscope at home, and young Ida read *Popular Science Monthly.* After Cornell admitted its first female student in 1870, Tarbell wanted to study biology there. But in the end, a representative of Allegheny College, a Methodist college in Meadville, Pennsylvania, encouraged her to apply there instead.

A home library and trips out of state probably weren't possible for the Moores, and while Sarah's family was literate, it's possible that books in the home might have been concentrated around the Bible and almanacs, which was sometimes the case in farm families of that era. Later in life Sarah's appreciation of literature was clear, but it is difficult to know what exposure she would have had early in life. She would have been about the right age to read *Little Women* when it was in its first printing.

Expectations for Life

Given her beginnings, what trajectory might Sarah have expected her life to follow? What would

define success? Marriage and motherhood would probably be her life's work. If she did any paid work before or after marriage, it wouldn't be with the prospect of wealth accumulation, a career, or personal fulfillment. Although Pennsylvania was moving past the homespun era, a young girl would still learn homekeeping and childrearing from her mother. In a farming community, she might use money from harvest sales to buy cloth so she could make clothes for her family. Because much of her life's trajectory would be determined by her husband, Sarah or her parents might have hoped that she would marry someone who treated her well and had similar values. They might have also hoped he would own his own farm or have a good job in a more industrial pursuit so she and her own family wouldn't need to live hand to mouth. If her husband died early from an illness or a labor accident, she would most likely need to remarry to maintain financial stability. If she had children to raise, remarriage would be especially important. So, she could expect her life to be a series of relationships in which she would be economically dependent on men, starting with her father and moving through one or more husbands.

Like other Americans born around 1857, Sarah spent her early years in what scholars consider an awakening of feminist consciousness in the U.S. and the slow, but empowering, changes that it brought

about. What is feminist consciousness, and how did it relate to Sarah? To paraphrase Gerda Lerner, it's the realization that women are part of a subordinate group and that this subordination is socially determined rather than natural. That consciousness develops a sense of sisterhood, and as a group, women develop strategies for changing their future.[17] While this consciousness might not have created specific expectations when Sarah was born, it did mean that she, like other, mostly white, girls born in this era, might eventually enjoy more citizenship rights and freedoms than her foremothers had. It also meant that a women's rights movement was underway during her lifetime, and at one point she would need to decide how to respond to it.

For context, Sarah was born just nine years after the *Declaration of Sentiments* was signed at the Seneca Falls Convention. The *Declaration* enumerated the political, social, and other wrongs against women that needed to be corrected. It sparked yearly women's rights conventions throughout most of the 1850s, helped to shape an organized suffrage movement, and was a factor in improving women's rights generally. For example, in late 1872 Pittsburgh newspapers covered the trial of Susan B. Anthony after she voted (illegally) in the 1872 presidential election. The question of whether or not women might stop

17 Lerner, *The Creation of Feminist Consciousness*, 274.

wearing the era's restrictive dresses and undergarments, which created health problems and confined women's movement, was being debated in the 1850s when "bloomers" debuted. *The Una,* the women's rights movement's first periodical, began publication in New England in 1853.

Were any of these specific developments being discussed in Fayette County or at the Moores' dinner table? They were certainly changing the world that Sarah would inhabit and creating an opportunity to live with more rights in marriage than her mother or grandmothers had. In the nineteenth century, Pennsylvania was among the states that began to pass Married Women's Property Rights laws that slowly chipped away at common law inherited from England to expand the legal rights of married women. Before the Married Women's Property Rights Acts, common law decreed that when a woman married, she legally died and was subsumed by her husband, legally a *feme covert.* The wife "had no legal separate existence."[18] Thus her last name changed to his last name; her assets became his, and he had legal title to her real and personal property and liability for her debts and contracts. In an associated practice and point of frustration in American genealogy, wives' names could be left off of deeds for property purchases in this era because it was legally the husband

18 Fletcher, *Pennsylvania Life,* 419.

who owned that property. During a property sale, the deed would document that the seller's wife had been questioned privately to confirm that she participated "of her own free will and accord."

Some of the basic rights married women would take for granted later came from legal changes in the nineteenth century. Only eight years before Sarah was born, laws were changed so that married women were allowed ownership of their clothing and a $300 exemption in the event of a husband's death or financial demise. By the time Sarah was seventeen, married women in Pennsylvania were finally able to control their own savings deposits.

Married or not, a Pennsylvania woman's right to vote in a presidential election wouldn't be possible until the Nineteenth Amendment was added to the Constitution in 1920, and in practice that right came even later for many women of color. Because juries were selected from voter rolls, this meant that women couldn't serve on a jury or be tried by a jury of their peers in grand and petit juries until Sarah would be sixty-four years old. Perhaps as a teenager Sarah would have had a hard time believing that it would actually be her name recognition and gracious estate that would help draw public support for woman-suffrage efforts in Fayette County.

With few opportunities and modest expectations for her life, Sarah was a young woman who needed to

get a job. The job she found as a maid was a mundane job that offered income, but on another level, it could have been a very intimidating step to take. Sarah's employer was James "Little Jim" Cochran, the entrepreneur who had pioneered the Connellsville coke region and had become extremely wealthy in the process. The socioeconomic contrast between Cochran's household and her own family's would have been stark, and soon this step actually would change the course of her life.

Entrepreneur's Maid

At a certain age, Sarah Moore's labor might not have been as necessary as that of her brothers on the farm where her parents worked. She might have looked elsewhere for a job because she wanted to start working, or her parents might have simply needed all of their children to contribute to the household income as soon as possible. In that era, a family was an economic unit in a very different way than it would be later. Although a "cult of domesticity" would develop in the nineteenth century and encourage women to stay at home, it's more likely that financial conditions in the Moore household made it necessary for everyone to work.

What was Sarah qualified to do? Domestic service was a viable job option for someone in her position because it would have required little investment on

her part. It also relied on female labor, and as the coal industry and railroads developed in southwestern Pennsylvania, it stands to reason that more male labor would have been absorbed in those industries. Alice Kessler-Harris suggests that a comfortable, Northern, antebellum home might have employed a servant and used the services of a dressmaker and laundress. More affluent homes might have employed additional housekeeping and cooking staff.[19] Between 1870 and World War I, and perhaps during Sarah's tenure in the Cochran household, fewer household servants would have been needed as more work was mechanized.[20]

The Boss

Sarah found a job as a maid in the Fayette County home of James Cochran. Like Sarah, he had been born in a log house, but after pioneering the Connellsville coke industry in the 1840s, he had become extremely wealthy. By the time Sarah walked through his door, he was a prominent and well-respected man in his fifties. Known as Little Jim because another relative was called Big Jim, he was respected locally because of his business success and because he lived and invested in the community where he was raised. A Democrat, he was still expanding his business ventures and

19 Kessler-Harris, *Out to Work,* 54.

20 Kessler-Harris, *Out to Work*, 113.

not showing signs of slowing down. In fact, he was bringing his sons into the business.

It's important to understand something about coal in southwestern Pennsylvania to understand the significance of Little Jim's work. In an 1882 history of Fayette County, Franklin Ellis attributed the first mention of coal west of the Alleghenies to Colonel James Burd in 1759. According to Ellis, Burd called the Connellsville Basin "one of the richest coal-fields in the world."[21] Early on, farmers in the region found coal on their properties, and when farm work was slow, they could dig it up for their own use or for sale. There was demand for coal as an alternative to the charcoal fuel that was becoming difficult to get as forests were cleared. Similar to backyard gardening, there were no real barriers to entry, so many small producers could operate without keeping official records or pursuing full-time production.

Bituminous coal is soft coal that is found in two- to ten-foot-thick beds in southwestern Pennsylvania, which is part of the Connellsville Basin of the Pittsburgh Coal Seam. By heating this coal to approximately 2000 degrees for twenty-four to seventy-two hours, a person could produce a byproduct called coke. It could be used to manufacture steel or smelt metals, and that was what made it so lucrative. In the 1840s, people in the region started to build and use

21 Ellis, *History of Fayette County, Pennsylvania with Biographical Sketches,* 241.

coke ovens to turn coal into coke. Because of their shape, they were called beehive ovens. Built of bricks, beehive ovens had a base of 10 ½ to twelve feet and rose seven- to eight-feet high. The process was manual; someone had to load coal into the top of each oven, heat it, and—when the coke was ready—someone had to remove bricks from the oven doorway and use water to cool down the coke before unloading it. Ellis pinpoints the earliest use of coke ovens as 1841, when John Taylor, Provance McCormick, and James Campbell built the two coke ovens that composed the region's first coke plant.[22] When the three men tried to sell their coke in Cincinnati, people there called it "cinders" and wouldn't buy it. Taylor, McCormick, and Campbell chose not to pursue their venture.

According to Ellis, John Taylor rented those coke ovens to Little Jim Cochran, Jim's brother Sample, and their uncle Mordecai Cochran in 1843. The Cochrans worked through the winter to mine and produce several thousand bushels of coke,[23] and in the spring they ferried it to Cincinnati in a boat that Little Jim had built himself. This was no small task: the trip entailed navigating the Youghiogheny, Monongahela, and Ohio Rivers, and Little Jim was about twenty years old when he did this. In Cincinnati, the Cochrans found Miles Greenwood,

22 "Coke Trade Nestor Dead," *Weekly Courier* (Connellsville, PA), November 29, 1894, 1.

23 Estimates vary by source, citing 6,000 or 13,000 bushels.

who had established Eagle Ironworks eleven years earlier. He would become known as an innovator later in his career, so perhaps he thought more creatively than the people whom Taylor, Campbell, and McCormick had approached. He also understood coke's value as furnace fuel and bought the cargo for seven cents per bushel. According to Ellis, "This is said to have been the first coke ever taken from Fayette County and sold for money, and in this view of the matter the Cochrans and Greenwood must be considered as the pioneers of the coke business in the Connellsville region."[24] Connellsville coke might have been exchanged for goods before this, but the Cochrans brought critical value in the form of a market that could generate revenue. Not just a single business, but an entire industry, was born.

Suddenly more people had a reason to build coke ovens on properties between Broad Ford and a town that was later named Dawson. The Cochrans boated that coke to Cincinnati and sold it there as well.[25] More coke ovens were built, and more coal and coke were sold. The Cochrans bought and sold other local operators' coke but also mined their own coal and produced their own coke. Years later, Little Jim remembered digging out the coal, loading it into a twelve-bushel cart and pulling it out of the mine

24 Ellis, *History of Fayette County,* 244.

25 Ellis, *History of Fayette County,* 244.

with a strap. As he recalled, they used lard lamps for light and replaced the lamps' wicks by tearing off pieces of their shirtsleeves.

Not only was Connellsville coke considered an extremely high-quality product, but its profit margins were higher than those of coke from other areas because its production costs were lower. Connellsville coal was cheaper to mine, and then it could be sent straight to the coke ovens. In contrast, Pittsburgh-area coal had to be crushed and washed to remove sulfur before it could go to the coke ovens. The extra steps increased the production time, costs, and final price. In the end, that coke was considered inferior to the Connellsville product anyway.[26]

Little Jim's entrepreneurial grit in the Connellsville coke industry created a reputation, made him a local mogul, and earned him a place as a prominent man in Ellis' Fayette County history book of 1882. This warranted a biographical sketch and a brief genealogy tracing his lineage to his grandfather, Samuel Cochran, a Revolutionary War patriot who had lived in Pennsylvania's Chester and Cumberland Counties. Family lore suggests that, like Little Jim, Samuel might have valued grit and farsightedness, two traits that might have kept Samuel alive during his winter encampment at Valley Forge. When he

26 Ellis, *History of Fayette County*, 246.

went to war, Samuel carried a second pair of shoe soles among his belongings, and he used them when his first pair wore out entirely. This was credited as saving him from some of the devastating conditions and amputations associated with Valley Forge. To survive, he was said to have gone so far as to boil his own leather cartridge box so he could drink the brine for nutrients. After the Revolution, it was his move west to Fayette County that brought the Cochran family to coal country. Samuel bought three hundred acres from Captain Joseph Huston, who had relocated there from Peach Bottom, Virginia. Huston's interaction with Cochran was auspicious for two reasons. The land transaction positioned Cochran's family in what would become the right place at the right time several generations later. And, Huston's descendant, Clarissa Huston, would turn out to be the right spouse for Samuel's grandson, Little Jim.

By the 1870s, Little Jim was involved with a number of profitable coal and coke ventures as an owner or co-owner. Some of the industry's activity is difficult to track because of the lack of data or type of data that was collected. Although Pennsylvania began the process to pass legislation to collect statistics on this booming industry in 1871, collection couldn't be enforced until that legislation actually passed. The state's mining report for 1871-1873 plainly stated

that coke "manufacturers, dealers and coke exchange are all too busy to furnish statistics."[27]

In most cases, each coal and coke company owned one or more mines that could be worked until their coal supply was exhausted. At each mine, hundreds of beehive coke ovens could be operated. Although Pennsylvania's coal supply was expected to last for hundreds of years, the available and accessible coal at any given mine could vary. This meant that some mines and associated mining companies operated longer than others, so operators might establish and dissolve many smaller businesses over time. In Little Jim's case, Cochran & Keister owned several mines and one hundred coke ovens. He was known to hold a large interest in Fayette Works, which had another hundred coke ovens. His other company, Brown & Cochran, began operating in 1854 and employed four hundred men to operate 441 coke ovens that turned out 10,950,000 bushels of coke per year.[28] James Cochran & Company owned the Clinton Mine and the Clarissa Mine with additional coke ovens around this time. By the time Ellis was writing his history book in 1882, and probably not long after Sarah Boyd Moore was Little Jim's maid, Cochran owned more than 1,200 acres of bituminous coal lands near the Pennsylvania & Lake Erie Railroad.

27 1871-1873 Pennsylvania Mining Report, 211.

28 1875-1876 Pennsylvania Mining Report, 140.

He was amassing a fortune and quite a bit of respect as the coke industry boomed. Nearby in Broad Ford, a very young Henry Clay Frick had entered the coke business in 1871 with fifty ovens. Eventually Frick's company would own over 1,000 ovens, which qualified him as a prominent man alongside Little Jim in Franklin Ellis' history book.[29] It also began to reshape the structure of the coke industry.

The Family and One Particular Son

Back at Little Jim's house, Sarah probably got to know his wife, Clarissa Huston Cochran. Clarissa was four years younger than Little Jim and had grown up locally in Tyrone Township. They had married in 1848, only a few years after that first boatload of coke went to Cincinnati. As he built up his mining and coking operations, Little Jim even named a mine in Clarissa's honor. She was the namesake of 108 coke ovens and 208 acres of coal land known as the Clarissa Mines or Works, owned by James Cochran and Sons. It wasn't unusual for operators to name mines for women or children in their lives, and sometimes they were named for surnames, the occasional goddess like Hecla, or less creatively as numbers.[30] Together, Little Jim and Clarissa had

29 Ellis, *History of Fayette County,* 415.

30 Enman, 78-79.

risen economically and created a family. Although several of their children did not survive past childhood, Philip, Henry, Alfred, William, George, and Annie did. The sons were active in the community and the family business.

Some people used descriptors like community-oriented when talking about the Cochrans. They were appreciated by townspeople because they stayed in the community where they worked and invested. Philip Galley Cochran was no different. The oldest son of the family, he was eight years older than Sarah. According to some sources, Philip was called home from college, before graduating, to help his father with the rapidly growing family business. He had already studied at Bethany College in the mountainous panhandle of West Virginia and at Otterbein University in Westerville, Ohio, in the 1860s and 1870s. Other Cochran men studied at these colleges as well. For example, a cousin named Mark Mordecai "M.M." Cochran attended Bethany before becoming an attorney and engaging in the family businesses in ways that would be significant later. Did the Cochrans choose these colleges for a reason? Did these men's college experiences inform their views at all? That is difficult to know without documentation of their own ideas. However, it's interesting that Otterbein happened to be the first college founded by the Church of the United Brethren in Christ, a

denomination that was known for being anti-slavery as early as the 1820s. Henry Garst's history of Otterbein indicates that, from its beginning in 1847, it had female teachers and students, Black and white students, and that its social life did not include fraternities or secret societies.

It's possible that Philip was the most cosmopolitan man Sarah had met, and at the time he was being groomed to take over the highly lucrative family business. It's unknown who noticed whom or how they were drawn together, but they fell in love. The years that followed proved that it was clearly true love between two people who respected each other.

Magnate's Wife

Philip and Sarah's decision to marry on September 25, 1879, might have surprised some people. After all, a 30-year-old who was rising in his father's coal and coke business was by most accounts a very eligible bachelor. Some might argue that there were marital candidates from more "appropriate" backgrounds for him. Marriage decisions were important, and the family's maid couldn't offer connections to advance Philip's social and professional interests. In that respect her background might have been viewed as an impediment; local lore has even suggested that she was never fully accepted by Pittsburgh society.

However, in more important respects, Sarah was a very logical choice. The couple was believed to have been in love. Like Philip's parents, both Sarah and Philip were from the same area and would have shared some understanding of each other because of

that. Religious faith seemed to be important in both families. Education and honest work mattered. It has been said—and suggested through later actions—that Philip valued Sarah's intellect, so it's possible that each might have just realized that a person's value didn't derive from a job title or social status, whether mundane or prestigious.

If Sarah's parents had ever worried about marriage providing economic security, there was no longer a reason to worry. 1879 was a good time to marry someone in line to lead a group of coal and coke companies. Pennsylvania had almost doubled its bituminous coal output during the previous ten years, and during the year Sarah and Philip married, the state mined 14.5 million tons, making it the largest bituminous coal-producing state in the country.[31] It was expected to take over 500 years to exhaust the coal supply, and the local Pittsburgh coal bed didn't just produce some of the best bituminous coal, but almost one third of Pennsylvania's available coal. Even the Connellsville coke that came from it was highly valued by this time. "The coke trade in this region has, within a few short years, simply become enormous, finding a ready market in every portion of the country—east, west, north, and south," the 1879-80 state mining report claimed of

31 U.S. Census Bureau, *Statistical Abstract of the United States 1879*, 161.

Connellsville.[32] Beyond their existing holdings, the Cochrans had just opened their Clinton Mines with fifty new coke ovens running full blast.[33] Expanding railroads would help deliver more coal and coke to market. Just a year earlier, in 1878, Pennsylvania had 6,011 miles of railroad in operation—more track than in all of the New England states combined.[34]

In some ways marriage presented a risk for a woman because so much of her existence was still dependent on or legally controlled by her husband. Given how little recourse a woman had if her husband made a poor decision, trust might be a key factor in a woman's decision to marry. Only five years earlier, married women's property rights continued to be bolstered. A Pennsylvania act was approved "allowing married women owning stock in any railroad company to sell and transfer the same."[35]

"On Thursday last," reported the *Keystone Courier* (Connellsville) on October 3, 1879, "Philip Cochran to Miss Sadie Moore [sic], all of Tyrone Township." That was it. For the people and era, it was as simple as a wedding announcement could get. In fact, a few days later more ink would be given to Little

32 Pennsylvania Bureau, *1880-81 Annual Report*, 177.

33 Pennsylvania Bureau, *1879-80 Annual Report*, 291.

34 *1879-1880 Statistical Abstract of the United States*, 155.

35 "List of Bills," *Pittsburgh Daily Commercial*, May 23, 1874, 2.

Jim's visit to Pittsburgh and his role in its air pollu-
tion.[36] Two other couples' weddings were included in
the column, with slightly more detail. Perhaps this
suggested that the Cochrans viewed themselves like
other local people and preferred not to distinguish
themselves as part of regional society. According to
lore, Sarah had to borrow a dress to wear to her wed-
ding because she couldn't afford to buy a new one.
Her will indicated that her wedding ring—perhaps
the original or a later purchase—was an emerald
platinum band, and church history indicates that
B.T. Thomas of the Methodist Episcopal Church in
Scottdale officiated. Those are the details that were
publicly available.

Newlywed

The couple stayed local, living in Owensdale and
then Vanderbilt. Later they moved to a home called
the White House, which they built on land they had
purchased in Lower Tyrone Township. Not long
after getting married, Sarah was pregnant. Later cen-
sus records, if accurate, indicate that this was her only
pregnancy, which is worth noting given the number
of siblings that she and Philip had. Perhaps Sarah
was empowered to control her fertility, or perhaps
additional children weren't possible for some reason.
American family size was generally shrinking during

36 "Personal," *Pittsburgh Daily Post*, October 6, 1879, 4.

the nineteenth century, but that didn't mean that households with only children were necessarily common. For example, in 1790—around the time Sarah's grandparents were born or were small children—half of the U.S. population lived in households with more than five people. By 1900, when Sarah's son would be ready for college, less than one third of the U.S. population did.[37] The Cochran home, however, would be a family of three. Sarah gave birth to a son, James Philip Cochran, on September 21, 1880 in Vanderbilt.

In the Home

It seemed clear that motherhood was a source of great joy and purpose for Sarah. Based on her 1935 letter, she understood that her son's development and childhood memories would be connected to her parenting choices and the home environment she created. But she might have expected her actions to affect his leadership when he was an adult in the community. In her 1935 letter (see Appendix), she advised parents that "Home will be an attractive, inspiring place—a place which these children will look back to and which will serve as a pattern for them, when they have added years and in turn are the fathers and mothers of this community." Her advice is telling because she is giving the same advice for

37 Kessler-Harris, *Out to Work,* 110.

sons and daughters, suggesting that she valued the contributions of both.

It's possible that Sarah was a very involved parent with specific ideas about how to be involved in a child's development. She believed that a child should learn to play a musical instrument and that music would strengthen family relationships and contribute to a pleasant atmosphere in the home. Specifically, she wrote in 1935 that mothers were responsible to ensure that "the atmosphere of the home is free from any gossip or scandal, that truth and love prevailed." She continued, "I wish I could tell all the mothers, especially the young ones, to keep their children close to them—never to let them hear unkind words spoken or any slander in their homes." Later in the same letter, she wrote that "Every mother should have a copy of Henry Drummond's book— *The Greatest Thing in the World*—and live it. Then a mother must show an interest in the activities of her child, in his schoolwork, his playmates, the mother should provide the right sort of reading matter and have the children sing, at home and in the church."

It's clear that Christian faith mattered to Sarah. *The Greatest Thing in the World* was Henry Drummond's speech, printed in book form, analyzing 1 Corinthians 13 and the nature of love. The fact that she implored mothers to live what the book says also echoes the nineteenth century belief in

a woman's moral authority in the home. But if her advice is read carefully, Sarah never went so far as to write that women's roles should be confined to motherhood or the home. The fact is that she spoke to motherhood simply because she was responding to a Mother's Day gift from Phi Kappa Psi's West Virginia Alpha Chapter. Her advice could be given to women who earned a living while raising children or to women who didn't.

In the era when Sarah was setting up housekeeping, the white, middle- and upper-class home was expected to be a sanctuary from an outside world that was perceived as dangerous and scary. It was becoming a place where motherhood could be idealized and women would be placed on proverbial pedestals. The problem was, as Gloria Steinem reportedly observed in the twentieth century, "A pedestal is as much a prison as any small, confined space."[38] It's difficult to take risks from a pedestal, and it is a position that could disconnect wealthier women from those who needed to earn a living in the outside world. But Sarah would have known what it was like to work for a living, to make sacrifices just to go to primary school, and to live in a community of people who spent long, hard hours doing backbreaking work without getting ahead. She might have also known what it was like to not be accepted by the "society"

38 *Time* staff, "Happy 80th Gloria Steinem: 8 of Her Funniest Truisms," Time.com, March 25, 2014.

where her husband's status should have given her a place. Would she still connect with working class women or try to connect with society women? Or could her position present a unique opportunity to bridge social classes?

Outside the Home

What awareness of the coal and coke business did Sarah have? How involved was she? Conventional expectations at that time would have set motherhood and domesticity as the focus of Sarah's role. According to Robert Lopresti's research, middle- and upper-class women in the 1890s typically worked if their husbands weren't earning quite enough money, if they were widowed, or if they had never been married. By that decade, society had concerns that women's paid work after marriage might negatively affect their reproductive abilities and the health and happiness of any family they already had.[39] According to outward appearances, Philip was successful, becoming more involved with his father, and taking over as mine superintendent at the Clarissa Mine and the Nellie Mine. Alice Kessler-Harris notes very directly that a man could be seen as a "failure" if his wife worked[40] and that contemporary ideas would have valued women of more affluent socioeconomic back-

39 Lopresti, *When Women Didn't Count*, 53.

40 Kessler-Harris, *Out to Work*, 51.

grounds for their spiritual and moral presence, not wage labor.[41]

Not only would a married woman of Sarah's socioeconomic status not be expected to work, but her particular industry wouldn't have been described as friendly to women. Starting in the 1890s, Pennsylvania state law forbade women and girls from working in or around coal mines. Beyond legal matters, a number of miners believed that women brought bad luck if they crossed a miner's path on his way to the mines. Women who were married to miners supported them at home, from washing their husbands' backs at workday's end to keeping house, raising children, and tending gardens. With many people, including boarders, living in a house, these women's work was never done. While not all families lived in coal and coke company towns, those who did had rental housing until the mine closed. In certain situations, the company had authority to force out entire families and haul away their personal possessions. A woman could be living in a house one day and a tent the next because of her husband's employment situation. Strikes were ugly and sometimes involved shootings and other violence. Mining accidents could be grisly, turning healthy young men into invalids or killing them—quickly at best, but sometimes slowly. For many years, there

41 Kessler-Harris, *Out to Work*, 49.

was little financial assistance for miners' widows and orphaned children unless donations were collected from other miners, and this created a real need for very young boys to be able to become wage earners when their fathers died.

Despite any expectations about mining, Philip has been credited with bringing Sarah into the coal business. Without journals, business records, or personal letters from this time period, it's difficult to know the timing or extent to which this happened. It's been said that Philip made her a vice president and was chastised for doing this, and certainly that could have happened if men were generally seen as failures when their wives worked. An 1883 deed for a $50,000 (1883 value) sale of land, coke ovens, horses and mules, tracks, and machinery associated with the Clinton Mines in Tyrone Township listed Philip and Sarah, as well as Little Jim and Clarissa Cochran, as sellers to Solomon Keister.[42] Another deed from the same day showed Little Jim and Clarissa Cochran selling similar land and property related to the Franklin Mines to the same buyer for $15,325 (1883 value).[43] In this era, it would have been understand-

42 James Cochran and wife to Solomon Keister, April 26, 1883, Pennsylvania State University Coal and Coke Heritage Center, Keister family papers, box 1, folder 29.

43 James Cochran and wife and Philip Cochran and wife to Solomon Keister, April 26, 1883, Pennsylvania State University Coal and Coke Heritage Center, Keister Family Papers, box 1, folder 28.

able to include Sarah and Clarissa on deeds for sales of homes. However, Sarah's and Clarissa's appearance on these deeds, which helped to dissolve the Cochrans' decades-long partnership called Cochran & Keister,[44] seems curious for a commercial property sale in that era.

The Business World

Regardless of the extent of Sarah's involvement in it, coal and coke were booming in western Pennsylvania. Bituminous mining in Pennsylvania grew from nine million tons of output in 1870 to forty million in 1890. Prices of coal land shot up from twenty dollars per acre in 1881 to $600 in 1891 and would continue to grow after the turn of the century.[45] In this era large-scale coal and coke operations were set up on thousands of acres, a scale that many smaller entrepreneurs just couldn't rival. A coke pool was formed in 1884 among Frick, McClure & Company, Schoonmaker, and the Connellsville Coke and Iron Company, with a Coke Producers' Association for smaller operators. By 1889, the local H.C. Frick Coke Company was aligned with Carnegie Brothers and had capital stock of $5 million.

44 "A Coke Trade Nestor Dead," *Weekly Courier* (Connellsville, PA), November 29, 1894, 8.

45 Enman, *Another Time*, 32-37.

Henry Clay Frick ultimately became the name associated with the Connellsville Coke Region, but perhaps Little Jim Cochran might have seen him as the younger, newer player in the industry that he had pioneered. After all, Little Jim sold his first boat-load of coke before Henry Clay Frick was born. One of Little Jim's companies, Cochran & Keister, had reportedly sold its Summit Works to the H.C. Frick Coke Company in 1880. While it's difficult to know the relationship between these men without Little Jim's personal papers, one letter from Henry Clay Frick provides a perspective. On April 20, 1889, Frick wrote to Andrew Carnegie that he had always "been anxious that Frick Coke Co. should absolutely control Connellsville Coke Region."[46] He went on to share his thoughts about some of the region's operators, includ-ing Little Jim and his sons: "Cochran, very vain called the nestor [sic] of coke region, has 6 ignorant sons who think they know all about the coke business. Had a talk with Cochran on Friday and will see him again this week." The Cochrans and Henry Clay Frick were more than just aware of each other.

The H.C. Frick Coke Company was growing through acquisition, and by 1898, it owned and

46 Henry C. Frick to Mr. Carnegie, April 20, 1889, University of Pittsburgh, Henry Clay Frick Business Records, identifier 31735066204367, https://historicpittsburgh.org/islandora/search/dc.identifier%3A%28317350662043506204367%29?f=&islandora_solr_search_navigation=0.

controlled two-thirds of Connellsville coke ovens, roughly 45,000 of the 60,000 acres of Connellsville coal land, and sold 75 percent of Connellsville coke on the market.[47] Cochran ventures still continued to grow. For example, Philip and Little Jim were involved in creating the Juniata Coke Company in 1891 and served as two of its directors.[48] Ultimately, American Wire and Steel, a subsidiary of U.S. Steel, would own half of this company. On August 2, 1893, Little Jim's largest venture, the Washington Coal and Coke Company, was chartered with capital of $250,000.[49] It consisted of two coal mines and a coke works, the Washington Run Railroad, and a growing company town for workers called Star Junction.

The End of an Era

Business leadership was about to change in 1894. For a few weeks that fall, heart problems plagued Little Jim Cochran. Dropsy (edema) set in, and he died at home on November 25, 1894. The *Pittsburgh Press* reported that a special train would run from Pittsburgh to Dawson for his funeral, which would

47 Robert Brownlee, 1898 Report of the Bureau of the Mines, xxiv.

48 "Producing Their Own Coke," *Pittsburgh Daily Post*, February 14, 1891, 6.

49 "Three Enterprises Incorporated," *Philadelphia Inquirer*, August 2, 1893, 5.

be conducted by the Masons. At that time, Little Jim's business holdings were reportedly worth $2 million (1894 dollars),[50] and he was reported as owning over thirteen hundred acres of coal land and 745 coke ovens.[51] Little to no public information suggests the family dynamics or viewpoints that would have influenced his succession planning. Much of his business passed to Philip, such as the presidency of the First National Bank of Dawson, where Philip was already a director,[52] and other vaguely noted coal and coke interests.[53] Like other industrialists of the era, Little Jim had become a bit of a monopolist, known for setting up the bank in 1891, getting involved in local electricity, and establishing a railway to connect the towns of Dawson and Vanderbilt for business purposes.[54]

Little Jim Cochran would remain locally known, but he was never part of the larger historical narrative like Henry Clay Frick. How did that happen? Henry Clay Frick moved from the regional to the national elite and became famous for various reasons. At

50 Untitled obituary for James Cochran, *Pittsburgh Press,* November 27, 1894, 1.

51 "A Coke Trade Nestor Dead," *Weekly Courier* (Connellsville, PA), November 29, 1894, 8.

52 First National Bank of Dawson ad, *Weekly Courier* (Connellsville, PA), December 21, 1894, 3.

53 "Philip G. Cochran Dead," *Pittsburgh Press,* June 1, 1899, 11.

54 "Dawson," *Weekly Courier* (Connellsville, PA) October 30, 1891, 8.

the same time, the coke industry became more concentrated after Little Jim's death. Specifically, the H.C. Frick Coke Company became the new business success story as it grew into a major player and acquired smaller companies. This also means that when modern researchers need to tap company records and employees' oral histories, a number of those documents tend to be from the H.C. Frick Coke Company. Because some Cochran businesses were acquired by Frick or were dissolved earlier in the industry's lifetime, the Cochrans can be more difficult to find.

Short-Lived Leadership

Now that Philip Cochran was at the top of the family business, he might have been interested in networking, and one particular trip was described in the local newspaper. From September through December 1895, Atlanta hosted the International and Cotton States Exposition to attract interest in the New South's industry and promote Atlanta as its capital. Pennsylvania had a building there, and the *Atlanta Constitution* reported that Philadelphia and Pittsburgh competed in their displays of heavy machinery related to iron, steel, and textiles. According to an event catalog, the H.J. Heinz Pickle Company even had an exhibit. Newspapers reported on groups of businessmen from around the country

traveling there to network and make business deals. Even without an exhibit, the Cochrans probably had an interest in attending, and Philip, Sarah, and Clarissa Cochran were three of the Exposition's one million visitors. Connellsville's *Weekly Courier* described Philip and Sarah as tourists traveling there for Thanksgiving with forty-one other visitors from Fayette, Westmoreland, and Allegheny Counties. A chatty social column[55] reported that everyone rode the train from Pittsburgh to Cincinnati, where Philip and Sarah visited Herberts (possibly related to Sarah), then took the train to Atlanta via Chattanooga. The article noted that Sarah collected souvenir spoons from all the states she visited on the trip and that Philip and some others got autographs from a Daughters of the Confederacy member. It's not clear why this would have been desirable given that Sarah's uncle was in the Union Army.)

The same *Courier* article included an important detail of the trip: "The party are all loud in their praise of the International and Cotton States Exposition. They acknowledge their agreeable surprise at the completeness and variety of industry shown in the Negro building." The Negro Building was credited as the first "designated space, since Emancipation, for the showcase of African-American achievement in a

55 "An Enjoyable Trip." *Weekly Courier* (Connellsville, PA), December 13, 1895, 8.

white-dominated setting."[56] It was exhibit space for visual and performance art by Black students from twenty-four Southern colleges, as well as work from hundreds of Blacks in business, philanthropy, and the arts. More importantly, it was a meeting place and site for discussion of the Black movement. A few months before the Cochrans' visit, this was where Booker T. Washington delivered his speech known as the Atlanta Compromise. Unfortunately, in the absence of personal letters or diaries, it is difficult to actually know what Philip and Sarah took away from their visit to Atlanta.

Philip's leadership of the family businesses was short-lived. When he was only forty-nine, he became ill for several months and passed away on June 1, 1899, at home in Dawson. He was buried at Cochran Cemetery with Little Jim and Clarissa, who had died after the Atlanta trip. Years later *The Pittsburgh Press* reflected on Philip's position in the coal and coke industry as one that "paralleled that of H.C. Frick."[57] Just before his death, he was president of the Washington Coal and Coke Company and was involved with Brown & Cochran, James Cochran Sons & Co., and the Juniata Coke Company. The

56 Jean-Laurent, "Flashback: The 1895 Cotton States Exposition and the Negro Building," *Atlanta Magazine,* February 27, 2014, atlantamagazine.com/news-culture-articles/-/flashback-the-1895-cotton-states-exposition-and-the-negro-building/.

57 "Taken by Death," *Pittsburgh Press,* November 1, 1936, 7.

Washington Run Railroad was also known to be a part of his portfolio.

In his will, Philip made his complete trust in Sarah clear. Written close to his death rather than early in their marriage, it would have captured what Philip knew of Sarah from the nearly twenty years they were married. He left her one-third of his real estate and one-third of his personal and mixed property; the other two-thirds of each would be left to James when he turned twenty-one in 1901. Most importantly, he named her executrix of his estate and directed her to "take full charge, care and control"[58] of James' portion until his twenty-first birthday. Considering that Philip had access to male relatives and accomplished attorneys, he could have made someone else an executor with—or instead of—her if he didn't trust her judgment. For example, George Hearst did not make his wife, Phoebe Hearst, the executrix of his estate, and when Phoebe died, William Randolph Hearst was one of several executors. Even with seemingly unlimited coal and coke revenue, empires could crash from bad decisions, and some of them did. But Philip seemed to know that Sarah was not someone who would let this happen.

Until their son's twenty-first birthday, Philip specifically gave Sarah "authority and power to carry on and continue the said properties and property

58 Will of Philip G. Cochran, dated May 26, 1899, proved June 7, 1899, Fayette County Register of Wills, Uniontown, PA.

interests in the various businesses in which I am engaged as fully and freely as I might or could do if living." The will went on to give Sarah the power to sell property or investments if she deemed it in the best interests of James or the estate. There were no restrictions.

James' Role

After Philip's death, thoughts would have turned to James' rising place in the business. Newspaper coverage specifically reported that he was preparing to take over his father's coke interests, but it isn't easy to identify James' own thoughts about his role. Did he have the same ambitions as his father and grandfather, or did he simply find the family business confining?

What details are known of James' upbringing and preparation for his career? He and his parents lived in Fayette County while he was growing up. He had a tutor and attended a prep school in Washington, Pennsylvania, most likely Trinity Hall. Sarah's 1935 letter indicates the pride she took in her son when she wrote, "It was a reward to hear the principal of his preparatory school say, 'We should live to have your son return for his example to the other boys.'" While Trinity Hall's records from his era don't seem to be available, the fact that James studied in Washington is corroborated through a newspaper article about

his grandfather's death. The *Weekly Courier* in Connellsville, Pennsylvania, reported that James was returning to his studies in Washington after visiting the Dawson area for his grandfather's funeral in 1894.[59]

From 1879 to 1906, Trinity Hall was an Episcopalian school for boys that counted Andrew Carnegie's nephew and the sons of both Ulysses S. Grant, Jr. and H. J. Heinz among its students.[60] At that time, it was known for being progressive with respect to corporal punishment, and its students were allowed to attend local churches chosen by their parents. To help the students move from regional elite to national elite circles, they were given opportunities beyond their coursework to become familiar with high culture. Ultimately James enrolled at the University of Pennsylvania's Wharton School as a member of the Class of 1903 to study business practice and banking.[61] In venturing to Philadelphia, he didn't simply study farther away from home than his father had. A University of Pennsylvania education would have provided credibility beyond western Pennsylvania, as well as a prestigious network of friends and potential work associates that could

59 "Dawson Doings," *Weekly Courier* (Connellsville, PA), December 7, 1894, 8.

60 Richards, 253, 259, 263.

61 "College Student Dies." *Daily Pennsylvanian,* March 6, 1901.

enhance his personal and professional opportunities. It was certainly possible that studying farther away might have introduced him to a wife who was from another part of the country or had connections in a different industry. In this generation it was also possible that she might have attended college herself.

Whereas Philip Cochran's college experience didn't include fraternities, James played football and was a member of Phi Kappa Psi. But his college experience lasted only until his sophomore year. On March 5, 1901, he died of pneumonia after being sick with a cold for a matter of weeks. According to one of the obituaries that ran in eastern and western Pennsylvania newspapers, Sarah had been called to Philadelphia when it became clear that James would not recover, and she was reportedly with him when he died. His body was sent to western Pennsylvania for burial at Cochran Cemetery. It was six months before his twenty-first birthday and a $2 million (1901 dollars) inheritance. In two years, he would have graduated. Certainly a shock within James' family, his death was almost as shocking outside the family.

Obituaries that ran in western Pennsylvania covered the facts of James' life and death. However, some of the obituaries from eastern Pennsylvania and New York didn't miss the opportunity to advertise his lost fortune and level of wealth. In places where his family was unknown, this was necessary to explain. "The

Cochran family is wealthy," one wrote directly.[62]

There were business connections in Philadelphia and upstate New York to the funeral director who sold the casket and the company that manufactured it. As a result, the coffin made headlines and became a marketing device for the coffin company and funeral director. West Chester, Pennsylvania's *News* described the solid silver plates on the inside and outside of the lid. The *Press* in Utica described the $3,000 mahogany coffin as "elaborately ornamented with clusters of leaves carved out of the solid wood. The inside was lined with copper, over which was French beveled glass. Royal purple plush covered the lining."[63] But the Utica obituary went as far as including a plug for the Utica Burial Case Company, the local casket company that had built the coffin. It "was one of the handsomest and most costly specimens ever turned out by that establishment" and boasted hand carvings that demanded six or eight months of a real Italian craftsman's time.

James' funeral director happened to be Oliver Bair on Chestnut Street. An enterprising businessman, Bair advertised his own "new funeral system" in area newspapers.[64] Similar to a burial trust with a payment plan, *The Philadelphia Inquirer* wrote that

62 "Magnificent Coffin," *Herald* (Rochester, NY), March 8, 1901.

63 "Was Made in Utica," *Press* (Utica, NY), March 8, 1901.

64 Bair, Company advertisement, *Philadelphia Times,* March 28, 1900, 11.

it placed "first-class funerals ... in the reach of all."[65] The West Chester *News* reported that James rested in "the magnificent casket that attracted so much attention at the time Oliver H. Bair had the public opening of his warerooms on Chestnut Street."[66] Not even two weeks after James' death, Bair was quoted in the Philadelphia *Record* to explain how his profession had evolved. To prove that his business represented a refined, new day in the industry, he said, "It was only last week that James P. Cochran, a student of the University of Pennsylvania, was interred in a casket costing $3,000, which is, perhaps, the costliest in the city, and which was on exhibition at my office."[67]

Was Sarah aware that the casket was used as a marketing sideshow for conspicuous consumption? It's unknown who located Mr. Bair or how this particular casket was selected. Perhaps someone acted on Sarah's behalf in this vulnerable time, or maybe someone took "the price isn't an issue" too far. Casket descriptions and costs weren't typically publicized for the Cochrans. Either there wasn't a general preference for ostentatious displays, or it was understood to be a tacky public discussion topic.

65 "Bair's New Funeral System," *Philadelphia Inquirer,* March 13, 1900, 3.

66 "At Rest in a Costly Casket," *News* (West Chester, PA), March 7, 1901.

67 "The Day of Fortunes in Caskets," *Record* (Philadelphia), March 14, 1901.

Beyond questions about caskets and funeral directors, James' death left more pressing questions that would recast the future. Who was going to run so much of the business that should have been out of Sarah's hands in a matter of months? Where did this leave Sarah personally and professionally?

PART II

Full Charge, Care, and Control

Fortysomething Widow

As Sarah turned forty-four in April 1901, perhaps she reflected on the surreal twists and turns her life had taken. When she was born, her life was expected to be lived on a small scale and with a series of relationships in which she would be economically dependent on her father and then a husband. Now she was a forty-four-year-old widow without a living child. She described this as a time when she was in the grip of "overwhelming grief;" and she was "prostrated and her tears fell unceasingly" (see Appendix). Perhaps being predeceased by her son made her consider the expected sequence of events in life. Because she had already lost her husband, she had also lost the one other person who could have grieved with her as a parent of her child.

Sarah wasn't the only woman to experience loss and grief in this place and time. Her mother-in-law, Clarissa Cochran, had lost several of her own children when they were very young, and she had been widowed for several years. Perhaps she could have offered wisdom from these experiences, but she had already passed away. Sarah's own parents were no longer alive, but some family members, including Rose Ann Herbert, were. In this part of the country, women who lost husbands or sons in mining accidents might have also buried children who hadn't survived their toddler years or relatives who had died from diseases or war. Some would confront questions of financial survival, especially if there were children to raise. Mining reports quantified the number of dependents a miner left behind after a fatality, but they couldn't capture his widow's grit. They didn't state if she was pregnant at the time or how many jobs she would have to hold down to support children by herself. In some cases, Black women would have faced the additional burden of racial discrimination. Immigrant women might have navigated many of these issues with friends and family an ocean away, in a second language, and with nativist discrimination.

While Sarah wouldn't have experienced all of the problems that miners' widows did, she might have wondered how she would move on from tragedy and

navigate the world of that era by herself. The family relationships and responsibilities that might have defined her place in the world had just been blown apart. Unlike many women around her, she was financially well-off and owned businesses but had no responsibility for immediate family. What was the right step forward for someone in this position? It took another person to point out the extent of her latent power. "One day a young doctor came to see her [Sarah]," she wrote in 1935 (see Appendix). "He told her not to lie and weep. There was so much good she could do, schools and churches she could aid. So, by this timely word, the gall of her affliction was transformed into the balm that comes from thinking and working for others. She said, 'I found new light in the world, new trust in God in my hope of doing good.'"

Activating Power

The doctor's words align with some of Henry Drummond's words in *The Greatest Thing in the World*, which Sarah highly respected. He wrote, "The most obvious lesson in Christ's teaching is that there is no happiness in having and getting anything, but only in giving."[68] Analyzing 1 Corinthians 13, Drummond suggested that God is love, that kindness is active love, and that God has given everyone

68 Drummond, 30.

the power to look out for others' happiness through acts of kindness. This kindness, coupled with her wealth, was the dormant power that the doctor's words had activated in Sarah.

Drummond had explained that suffering could melt a person down and create a new heart, but there seemed to be a universality and timelessness to the notion of transforming pain into a balm. Perhaps Sarah was able to seize the opportunity for spiritual growth in this devastating period. In the twenty-first century, her description of her transformation resembles what's known as post-traumatic growth. Rather than being just resilient enough to return to the type of life she had known before this traumatic experience, she seemed to experience transformational change because of it. She could have stayed at home and tended to the spoon collection from her Atlanta trip in 1895. Instead, she chose to go out into the world and improve it, and she did so by using the power she already had. In the years that followed, she began to engage with the world in ways that were deeply meaningful to her.

Using the Chart and Compass

The second issue that might have confronted Sarah was age. What role could a woman in her forties or older have in society at that time, especially on her own? Would others still understand her to

have value? When Elizabeth Cady Stanton turned seventy, she reflected on women and aging and wrote an address about the wisdom and usefulness that comes with age. She believed that fifty was the real heyday of a woman's life and suggested that women beyond child-rearing years turn to philanthropy and other constructive pursuits. In that 1885 address, she wrote, "After many experiences on life's tempestuous seas, we learn to use the chart and compass, to take soundings, to measure distances, to shun the dangerous coasts, to prepare for winds and weather, to reef our sails, and to know when it is wise to stay in the safe harbor."[69] With age comes wisdom.

In Sarah's era, M. Olivia Sage, Phoebe Hearst, and Jane Stanford were just a few examples of other wealthy women who were effecting change as widows. Around the time that the doctor advised Sarah, M. Olivia Sage wrote that intelligent women without family obligations were "bound by every law of morality to find a beneficent outlet for their powers."[70] Interestingly, years later in *Gift from the Sea,* Anne Morrow Lindbergh associated lives of creativity and contemplation with unmarried,

69 Stanton, Elizabeth Cady. *Elizabeth Cady Stanton Papers: Speeches and Writings, -1902; Speeches; 1885, 12 Nov., "The Pleasures of Age," an address delivered on her seventieth birthday.* 1885. Manuscript/Mixed Material. https://www.loc.gov/item/mss412100094/.

70 Sage, "Opportunities and Responsibilities of Leisured Women," 713.

childless saints because their time wasn't allocated to the details of other people's lives.[71] From forty-four through her seventies, Sarah would become highly productive and engaged with the world. Perhaps she and Philip would have been philanthropists together if he had lived longer, but there is no way to know that or to guess what Sarah would have accomplished in her own right if that had been the case. Without the responsibilities of marriage and motherhood, perhaps she gained a certain degree of freedom that allowed her to make her own path.

While wisdom might have accompanied age, Sarah took the critical step of passing on her wisdom and resources. Sarah appeared to exhibit generativity, a concept that Erik Erikson defined later in the twentieth century as an interest in guiding the next generation, either through a literal or figurative parental responsibility. Sometimes psychologists refer to this as a time in midlife when a person focuses less on acquiring things and more on investing in the future through causes, communities, or people. Altruistic mentoring and philanthropy are common examples of this, and sometimes Erikson's quotation "I am what survives me" is cited as a mark of his concept. Many of Sarah's accomplishments can be more powerfully considered with this quotation and concept in the background.

71 Lindbergh, *Gift from the Sea*, 23.

Some very small thread of generativity might be found in the Drummond text that Sarah found so striking: Love begets love. "Therefore keep in the midst of life. Do not isolate yourself. Be among men, and among things, and among troubles, and difficulties, and obstacles," Drummond wrote. He cited Goethe's quotation, which was so appropriate at this stage in Sarah's life: "Talent develops itself in solitude, character in the stream of life." In short, go out into the world and engage.

It Is Never Too Late for a Journey

Over the course of the next eight years, Sarah traveled extensively as did other wealthy women of the era. According to oral history, her travels in Europe and Asia were meant to help her move on from the loss of Philip and James and to have a break from the business. But that literal journey seemed to mark the beginning of a new journey in life.

As part of that journey, Sarah's character and potential became publicly visible. In the years that followed, newspapers and histories of colleges would publish her photograph. In any given case, the image might recall Gilded Age wealth, a nineteenth-century vision of womanhood or the dignity of a fiftysomething suffragist who was not trying to be an ingenue. Publications would describe her actions and quote her. Sometimes they would associate

her with the businesses she owned; sometimes they delineated traditionally masculine and feminine spheres, associating Philip with business and Sarah with philanthropy.

Sarah never remarried or had more children. Instead of being called "Mrs. Philip Cochran," she was "Mrs. Sarah Cochran" in newspapers, college bulletins, and other publications across a large geography. Certainly in her era, there were wealthy widows who still used their husbands' names to invoke the wealth and power that they derived from their dead husbands. Given the regional knowledge of the Cochrans, locals would have already known Sarah's level of wealth and relationship to Philip regardless of how her name was written. Perhaps she just didn't feel a need to remind people of what she had or whom it came from, or maybe she wanted an identity of her own. It's impossible to know without her own words on the subject.

On a strategic level Sarah appeared to approach her causes the way a coal baron approached his portfolio of businesses: with one supporting the other. She became involved in organizations, built a palatial home for entertaining, and funded building projects for colleges and churches. Taking on these projects from her forties to her seventies, she became an example of generativity and influence. She invested in the future by involving herself with men's and women's

education and religious initiatives. Sometimes she did this by quietly financing individuals' educations, but she publicly emerged as a college trustee and bene-factor of certain Phi Kappa Psi chapters. Publicly, she owned the part of herself that made her unique and possibly an outsider in her industry—gender—by taking up the cause of women's suffrage and hosting a rally at her home when she was fifty-eight. She fit right into the suffrage movement, which had afforded women "of a certain age" the dignity and public voice that society generally reserved for older white men. At fifty-nine, Sarah hosted the semi-annual meeting of the Methodist Episcopal bishops at her home, making it the first private residence ever to host that meeting. Perhaps she strategically chose when to act quietly and when to use publicity to her advantage.

As Elizabeth Cady Stanton wrote in her own seventieth-birthday address, "Fifty, not fifteen, is the heyday of woman's life. . . . It is never too late to try what we may do."[72] In her own way, Sarah built a new space for herself in the world. From the twenty-first century, it might resemble the ultimate midlife pivot.

72 Stanton, Elizabeth Cady. "The Pleasures of Age."

Coal Queen

Years after Sarah's lifetime, a newspaper wrote that she had once been called America's only Coal Queen. *Carbo Regina*. The colorful title might conjure images of society matrons at Gilded Age costume parties, but it also calls out Sarah's position as a wealthy, widowed woman in an industry where women couldn't work, and their presence was considered unlucky. Unlike her late husband, Sarah had not grown up with any expectation of a business career, and she lacked his practical experience, network, and education. With that in mind, how involved did she get in business, and what power did she wield? What personal life was she able to construct? To find answers, it's helpful to understand what was happening in the coal and coke industries between Philip's and James' deaths and her own in 1936 because these industries were the source of her wealth. Then her activity in her own businesses can

be analyzed to understand how she navigated the industry. With that backdrop, it's possible to see the personal life that she created in terms of properties she owned, her travels, and the beginnings of her philanthropic work. Perhaps because she was not as much of a business insider as her husband had been, she was better positioned to create a path for herself in philanthropy.

The Coal and Coke Industries

The coal and coke industries provided enormous wealth for operators like Sarah. Not long after she took over the business, the assumption remained that Pennsylvania's available coal supply would last for several hundred years. The 1906 report from Pennsylvania's Department of Mines indicated that world coal production was at its highest ever, and Pennsylvania alone produced 201,672,499 tons, or about half the output of Great Britain.[73] During World War I, coal production dramatically increased despite miners having to join the military and 1918's influenza epidemic. Despite violent strikes in the 1920s, there was some strength until midway through that decade. Late in the 1920s, the future wasn't looking as bright as it once had. Overproduction and poor freight rates were blamed,

73 Pennsylvania Department of Mines, 1906 Report of the Department of Mines, iii.

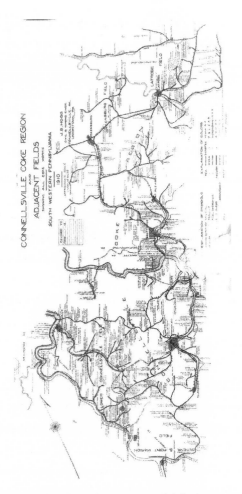

Connellsville Coke Region and Adjacent
Fields, Map, 1910, copy, PWVC Community
Collection, Coal and Coke Heritage Center,
Penn State Fayette, The Eberly Campus.

and oil, gas, and water-generated electricity were acknowledged as significant new alternatives to coal. There was even decreased demand among some coal buyers because more efficient combustion engines allowed these buyers to do more with smaller quantities of coal. In 1930, Pennsylvania's bituminous industry was finally declared "a very sick patient"[74] by the Pennsylvania Department of Mines.

But the real profits had never been in coal. They were in allied lines of business, like iron, steel, and coke manufacturing.[75] In 1910, Pennsylvania produced 18,689,722 tons of coke. The H.C. Frick Coke Company remained a dominant player in the industry, and in 1916 it announced plans to develop a subterranean transport system for moving coal to a coke processing plant to be built in Clairton, near Pittsburgh.[76] During World War I, coke manufacturers who could conserve tar and gas could find new markets for byproducts in the dye industry. If they could capture benzol from coal gas, they could get involved with companies producing military explosives, motor fuel, paint, solvents, and insulating materials. Unfortunately, new types of coke ovens

74 Pennsylvania Department of Mines, 1930 Report of the Department of Mines, 3.

75 Pennsylvania Department of Mines, 1906 Report of the Department of Mines, iv.

76 Pennsylvania Department of Mines, 1916 Report of the Department of Mines, 6.

were needed to capture these byproducts, so this development actually signaled the end of operators who depended on beehives.

By the end of World War I, Pennsylvania was producing two-thirds of all American coke output. Of that, 70 percent came from Fayette, Westmoreland, and Indiana Counties.[77] Unfortunately, coke output had been decreasing annually since 1910; only a little more than 2.6 million tons were produced in 1928.

As the industry expanded, it became more complex; its associated bureaucracy was forced to grow, and state mine inspectors were each responsible for visiting sixty to eighty mines, investigating accidents, and consulting on legal and mining matters. Insurance companies were beginning to inspect mines. First aid teams and supplies were added to mining operations early in the twentieth century, and by the 1910s more phones were added for better communication. Mine operators needed to keep up with the industry's technological changes if they wanted to compete. Mechanical equipment that became more necessary over time was expensive, and it increased production costs since Sarah entered the business. For example, in 1902, not quite 38 percent of large mines in Pennsylvania used equipment that relied on electricity or compressed air to mine coal.[78]

77 Pennsylvania Department of Mines, 1918 Report of the Department of Mines, 7.

78 Pennsylvania Department of Mines, 1902 Report of the

By 1912, a Department of Mines annual report stated that, "It seems that electricity as a power has come to stay."[79] Concerns about accidents related to electrical hazards, flooding, or explosions led to special reviews of ventilation and drainage, and inspectors typically gave Sarah's Pennsylvania mines high marks for these concerns. Over time, the industry adopted new processes for using explosives in mines.

When miners died on the job, no compensation system existed beyond other miners' charitable donations or the possibility of small payments from mining companies. While Pennsylvania's 1902 *Report of the Bureau of the Mines* proposed a tax to aid injured workers or families of workers who died in the mines, in practice the lack of compensation shifted the burden of a family's livelihood to its boys. State mine inspectors became concerned that parents were providing operators with certificates of age containing false information so their sons could start working while underage. Disputes about legal minimum working ages for boys in or around bituminous mines continued for several years. "The bituminous workers contend, however, that the employment age should not be raised for the reason that there is no employment for the boys in that region except inside

Bureau of the Mines, iii.

79 Pennsylvania Department of Mines, 1912 Report of the Department of Mines, 80.

of the mines,"[80] wrote James E. Roderick, chief of the Department of Mines, in his 1905 report.

Business Owner

When Philip Cochran died, Sarah's expectation was that she would own a portion of the estate and temporarily control James' portion until he turned twenty-one. But in 1901, she found herself likely to own business operations in Pennsylvania, West Virginia, Virginia, and Tennessee[81] indefinitely. In newspapers she was credited as being a director and the largest stockholder of the Washington Coal and Coke Company, a founder of the First National Bank of Perryopolis, and a director of the First National Bank of Dawson. The exact scale of Sarah's business operations is vague given that a number of businesses existed over time, some aligned with Pittsburgh iron and steel companies, some as partial ownerships, and some in lease agreements with other companies. Others merged with other Cochran businesses or were dissolved along the way.

Information in newspaper reports and mining records varied in detail. Her businesses were said to have grown 300 percent during her ownership, but the extent of Sarah's involvement is difficult to track,

80 Pennsylvania Department of Mines, 1905 Report of the Department of Mines, viii.

81 Margaret Snyder, "The Lady Bountiful of Beechwood Boulevard," *Pittsburgh Press*, August 2, 1908, 43.

not only because of extant data, but because she was not always discussed with her own companies. In some cases, she was clearly trying to stay involved and was associated with specific businesses or activities, but in others her role seemed to be behind the scenes. Sometimes it was easier to track male managers with clear job titles because those jobs were tracked in mining reports.

One of Sarah's advisors was Mark Mordecai "M.M." Cochran, a cousin to Philip and Little Jim Cochran. M.M. was only a few years older than Sarah, but he was an accomplished attorney and had been involved in organizing the Washington Coal and Coke Company. He served as its president from Philip's death until the company was sold. The active head of Cochran businesses until his death in 1936, he was very involved in creating, merging, and dissolving companies. Later in life, Sarah supposedly recalled that he "had been so good to me and took such good care of these properties for these thirty-five years."[82] In 1904 he was listed in *Who's Who of Pennsylvania* as president of the First National Bank of Dawson.

But unlike M.M. Cochran, Sarah was not listed in the 1904 *Who's Who in Pennsylvania*. Perhaps *The Connellsville Courier's* coverage of a 1904 smoker provided a better snapshot of Sarah's place as one of the few or only women in the industry. In the

82 Robbins, "Old Coal Kings," TribLive, January 2, 2005.

early twentieth century, a smoker was a party meant for men only because it featured smoking, a pastime that was considered immoral for women. This one was given by Washington Coal and Coke Company's General Manager, John S. Newmeyer, and his wife at their home in Dawson. A Pittsburgh caterer served food, and an orchestra played music for guests: distinguished male employees of companies Sarah owned or founded, as well as railroad men and Industrial National Bank men. While M.M. Cochran attended, Harry Brown (presumably the partner of Brown & Cochran), the local coal baron J. V. Thompson, and various Baltimore & Ohio Railroad executives reportedly declined invitations. Based on newspaper coverage, Sarah wasn't a guest at all; she "assisted in the pleasant duty of entertaining" with the Newmeyers' three daughters.[83] Was this the socially acceptable means that she or Newmeyer used to navigate social norms and a boys' club, or was she just perceived as an industry outsider?

There are other examples of Sarah's not being taken seriously. In 1902 *The Religious Telescope* wrote that "it was hard to deceive her, even though it be tried by educators or men holding high positions."[84] According to local lore, Henry Clay Frick saw the

83 "He Gave A Smoker," *Connellsville Courier* (Connellsville, PA), December 8, 1904, 5.

84 W.R. Funk, "The James F. and Sarah Herbert Moore Church," *Religious Telescope*, April 30, 1902, 68, 18.

business as her husband's. Whether that was his viewpoint or not is unknown, and it's possible that it was a reference to the era's ideas about men's and women's places in business and the home. In the twenty-first century, a newspaper quoted portions of Sarah's letters describing her two-week fight with her own company's male directors when she wanted to put M.M. Cochran in what would have been her son's job.[85] This was not long after James' death, and she was trying to ensure that the other directors didn't take the business to Pittsburgh, where she would have less to do with it. The need to fight was probably not unusual for wealthy women at that time. A good comparison may be Jane Stanford, widow of the railroad tycoon Leland Stanford. Like Sarah, Jane was the sole executor of her husband's estate.[86] She was also a suffrage supporter in direct contact with Susan B. Anthony. A few years before Sarah fought her directors, Jane had to fight her dead husband's business partner just to get free railroad passes for suffragists to use in their California campaign.[87] In the end, gender seemed to limit the power that usually accompanied wealth.

If Sarah's involvement seemed unclear in business records, her role was equally vague in some government records that would have affected public

85 Robbins, "Old Coal Kings, *TribLive*, January 2, 2005.

86 Johnson, 119.

87 Johnson, 125.

policy and contributed to a body of knowledge about women and Pennsylvania industry. A case in point is the occupation information in the U.S. census. In the late nineteenth and early twentieth century, the census was taken by individuals walking door to door. According to Robert Lopresti's research, in the 1870 census men's occupational information was generally correct, but data for women and children were often incorrect because census takers sometimes assumed that they didn't work. He pointed out that modern scholars believe the census undercounted women with paid occupations between 1880 and 1910.[88] In 1880, Sarah was "keeping house,"[89] which probably made sense given that she was recently married and due to give birth soon. In 1900, when she was in charge of the same ventures that Philip had managed, her occupation was simply left as a blank space.[90] By 1910, she was an "employer,"[91] but "none" in 1920, as was a neighboring miner's 27-year-old wife.[92]

88 Lopresti, 112.

89 1880 United States Census, Upper Tyrone Township, Fayette County, Pennsylvania, digital image *s.v.* "P.G. Cochran," FamilySearch.org.

90 1900 United States Census, Dawson borough, Fayette County, Pennsylvania, digital image *s.v.* "Sarah B. Cochran," FamilySearch.org.

91 1910 United States Census, Dawson borough, Fayette County, Pennsylvania, digital image *s.v.* "Sarah B. Cochran," FamilySearch.org.

92 1920 United States Census, Lower Tyrone, Fayette County, Pennsylvania, digital image *s.v.* "Sarah B. Cochran,"

For comparison, Little Jim's and Philip's occupational data had been consistent, industry-specific, and clear on the census. In 1870 Little Jim was a coke merchant;[93] in 1880 he was a coke operator,[94] and Philip was a coke manufacturer.[95] The 1890 census was lost, and both men were dead by the time the 1900 census was taken. Looking at another industrialist in the twentieth century provides data for comparison. Henry Clay Frick was a sixty-year-old veteran of the coal and coke industry with name recognition in 1910. In that year's census, he was recorded as a capitalist, and his wife's occupation was shown as "none."[96] Although vague, at least it indicated Henry Clay Frick's productive labor and business acumen. Sarah, on the other hand, was still represented like a capitalist's wife, who presumably didn't work for income.

FamilySearch.org.

93 1870 United States Census, Tyrone Township, Fayette County, Pennsylvania, digital image *s.v.* "James Cochran," FamilySearch.org.

94 1880 United States Census, Upper Tyrone Township, Fayette County, Pennsylvania, digital image *s.v.* "James Cochran," FamilySearch.org.

95 1880 United States Census, Upper Tyrone Township, Fayette County, Pennsylvania, digital image *s.v.* "P.G. Cochran," FamilySearch.org.

96 1910 United States Census, Pittsburgh Ward 14, Allegheny County, Pennsylvania, digital image *s.v.* "Henry C. Frick," FamilySearch.org.

Sarah Cochran, date unknown.
Allegheny College Archives, Wayne
and Sally Merrick Historic Archival
Center, Pelletier Library,
Allegheny College.

Did this difference in occupation information
have anything to do with gender? In her biography of
Russell Sage's widow, M. Olivia Sage, Ruth Crocker
indicated that around the turn of the century the
business world and wealth accumulation were con-
sidered masculine. Benevolence, however, was consid-
ered feminine.[97] This might help to explain implicit
biases that could have led to Sarah's business associ-
ations getting downplayed. Outside of government

97 Crocker, *Mrs. Russell Sage*, 198.

records, Sarah had even more creative titles, like Coal Queen, that described her benevolence or home life. She was called "a woman of large affairs," "the Lady Bountiful of Beechwood Boulevard," and later "the chatelaine of Linden Hall." In Allegheny College's own history book, she was described as a trustee who was "busy with many cares, but her especial concern is for the large force of laboring men under her. She is a rare Christian woman who is administering a great trust with fidelity."[98] In this case, she was not portrayed strictly as an employer or capitalist, but as a caretaker of men and a good Methodist. Perhaps this was a roundabout way of describing a paternal capitalist who was a woman. Or, perhaps the nineteenth-century image of wealthy, white femininity overshadowed the details of reality: the nature of mining meant that Sarah actually owned thousands of pounds of dynamite and thousands of powder kegs at any of her mines. As an owner and director, she would have had some accountability for operations, but ironically, she would have been legally barred, like other Pennsylvania women and girls, from working in or around the mines until 1909. Only that year could fourteen- to sixteen-year-old girls begin working in mine offices, not mines themselves.

Over time Sarah's portfolio of businesses changed. Smaller ventures were bought and sold.

98 Smith, 406.

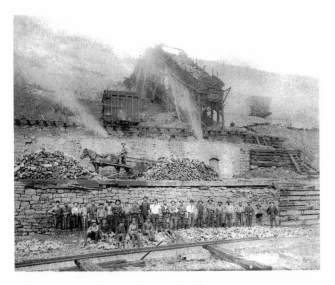

Miners with tipple, horse, and coke ovens. Undated. PWVC
Community Collection, Coal and Coke Heritage Center,
Penn State Fayette, The Eberly Campus.

The Florence Mine, which newspapers discussed
very directly as "Mrs. Sarah B. Cochran's mine,"
operated from 1914 until 1928, when its equipment
and six hundred acres of surface land were sold to its
superintendent. Sarah reportedly retained the coal
rights after the sale, expecting that she could reopen
the operation if a railroad were ever built closer to the
mine.

Other operations ran their course and closed. For
example, the Clarissa Mine, with three drift mines
and a shaft, was abandoned in 1912. If any coal mine
might have had sentimental value, perhaps it was this

one. Started by her father-in-law's James Cochran Sons & Company, it was named for her mother-in-law. Philip was its superintendent early in their marriage, and for years Sarah's older brother, James C. Moore, was the mine boss.

Frick acquired some of her most productive companies and carefully managed mines, like the Washington Coal and Coke Company and Juniata Coal and Coke Company. Juniata happened to be adjacent to a Frick mine, and when Juniata could no longer produce coal safely, Frick acquired it for $150,000 (1908 dollars).[99] The sale included 250 coke ovens, thirty houses, a store, livestock, railroad tracks and equipment, and 120 acres of surface land. Although the mine was useless, its plant was valuable for processing coal from Frick's adjoining property.

Coking was strong until the late 1920s, and the Washington Coal and Coke Company stayed in Sarah's portfolio until 1930, when she was seventy-three years old. At that time, Washington performed so well that it was one of western Pennsylvania's largest independent operators[100] and would have been a jewel in the Cochran crown. When plans were announced to sell it to Frick, it was front-page news for the money involved; $2,500,000

99 "Frick Coke Company Buys Juniata Coke Plant for $150,000," *Morning Herald* (Uniontown, PA), July 28, 1908, 1.

100 "Passing of Washington Run Railroad," *Morning Herald* (Uniontown, PA), March 14, 1931, 6.

to $3,000,000 (1930 dollars) was expected to be paid for its fifteen hundred acres of coal and two thousand land acres, its plant, and equipment.[101] Although Sarah's portfolio was scaling down, the Cochran Coal & Coke Company of Morgantown, West Virginia, of which she was credited as a founder and stockholder,[102] appeared to remain in business beyond her death.

The Personal Life of a Coal Queen

With business booming and operations under trusted supervision, Sarah began to turn her attention beyond mining. She was known to have traveled in Europe and Asia over the course of eight years, although how frequently she traveled and how long her trips lasted is not clear. Oral history of her travel suggests that she received a decorative fireplace mantel for her home when she was a guest of the Rothschilds in Europe. Travel in England supposedly inspired her vision for Linden Hall, the mansion she built years later in Fayette County. It's difficult to know if her travel was entirely for personal reasons or if there was a business reason for her to venture abroad. For example, she might have

101 "Largest for Decade in Fayette," *Evening Standard* (Uniontown, PA), June 7, 1930, 1.

102 "Mrs. Sarah Cochran's Death Ends Long Life Devoted to Humanity," *Daily Courier* (Connellsville, PA), October 28, 1936, 2.

been peripherally involved with the Pennsylvania State Sabbath School Association, whose early twentieth-century leadership included H.J. Heinz and John Wanamaker. Apparently Sarah was a patron of the 1907 Universal Sunday School Exposition,[103] a convention in Rome that drew fifteen hundred representatives of the World Sunday School Association to the Colosseum.[104] Perhaps Sarah made a trip to Italy to be part of this event.

Some surviving documentation provides better clues about Sarah's European travel in 1905. On a particular trip she visited England, Switzerland, France, Germany, and Italy for three months with her sister and brother-in-law, the Lowstuters.[105] For the return trip, they were passengers on the *Oceanic,* the same ship that Phoebe Hearst had taken on one of her grand voyages, and arrived in New York on August 30th. Sarah's return made the front page of Connellsville's *Weekly Courier.*

But the real story and the lasting philanthropy from that trip involved a significant artwork purchase Sarah had made in Dresden. The city was

103 "Conventions Records, no. 3, 1905-1912," Pennsylvania State Sabbath School Association. Historical Society of Pennsylvania, collection 1839.

104 Skrabec, *H.J. Heinz: A Biography,* 189.

105 "Back from Europe," *Weekly Courier* (Connellsville, PA), September 1, 1905, 1.

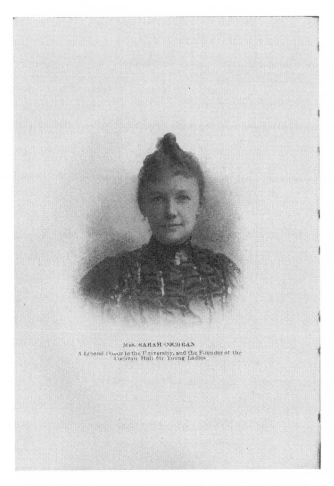

MRS. SARAH COCHRAN
A Liberal Donor to the University, and the Founder of the
Cochran Hall for Young Ladies

Sarah B. Cochran circa 1907. Otterbein University, 1847-1907. Image courtesy of the Otterbein University Archives.

home to Raphael's Renaissance masterpiece, *The Sistine Madonna,* and had been home to the German artist L. Sturm. In the 1890s, the Kaiser had chosen Sturm to produce a few full-scale copies of that

painting, one of which was for Jane Stanford. At that time, Jane and her husband, Leland, were establishing Stanford University as a memorial to their young son, and Jane planned to include two museums on its campus, one with copies of European masterworks. In an interview with the *San Francisco Chronicle* in 1889, she explained why she had just worked through heads of state and a former diplomat to request the copy. As she said, "I realize the fact that very many of the boys and girls of California may never have an opportunity of seeing these wonderful originals. They can never be purchased. The next and only way of seeing them is through these copies, which are all painted by the very best artist that could be found."[106] Jane was very much like Sarah in supporting education and women's suffrage; both women also acted on their desires to memorialize their young sons. Soon they would have a painting in common, too.

Andrew Carnegie reportedly had tried to buy Sturm's other copy of the painting in the past, but Sturm wouldn't sell it. By the time Sarah visited Dresden, Sturm was dead and his estate was being settled. Sarah was able to snap up that other copy for $2,000 (1905 dollars).[107] As the *Pittsburgh Bulletin* reported, the purchase was exciting for multiple

106 "Girls at Palo Alto," *San Francisco Chronicle*, November 24, 1889, 6.

107 *Philip G. Cochran Memorial Methodist Church 75th Anniversary 1927-2002*, 5.

reasons. "This Sturm 'original copy,'" it wrote, "is the one from which the Madonna pictures have been presented by Mr. Andrew Carnegie to St. Paul's Cathedral and to St. Thomas's Church, Braddock."[108] When the *Bulletin* went to press, the painting was at a gallery in Pittsburgh and would be framed and donated to a Methodist church that Sarah had recently built in Dawson to memorialize her husband. Later in the year Connellsville's *Weekly Courier* didn't mince words regarding the Coal Queen's coup: "Mr. Carnegie failed in his attempt to purchase the original that was later secured by Mrs. Cochran."[109]

At home after her extended travels, Sarah needed to be closer to Pittsburgh. Some business was transacted there, and she was said to have been a member of country clubs in Pittsburgh and Greensburg. In 1908 she paid $56,000 (1908 dollars) to buy a house called *Seven Gables* in Squirrel Hill. The Swiss-style brick house on Beechwood Avenue was said to feature twelve rooms and three baths,[110] and it would situate her near the city when she needed to do business. Around the same time, she traveled to Florida in the winter, as did other industrialists from northern states. Different maids were said to

108 "Art and Artists," *Pittsburgh Bulletin,* October 28, 1905, 52, no. 2, 18.

109 "Sistine Madonna Unveiled at Dawson," *Weekly Courier* (Connellsville, PA), December 30, 1905, 1.

110 "Hill Top Activities," *Pittsburgh Press,* September 19, 1919, 22.

accompany her on each trip so all of her staff would have opportunities to travel and expand their horizons. Ultimately Sarah decided to build her own vacation home there, and in 1908 she bought property and hired the area's major architect, S.H. Gove, to design and build a mansion expected to cost $75,000 (1908 dollars). *The Daytona Gazette-News* described the plans for "a palatial home that will eclipse any residence in Daytona."[111] By August of the same year, a Pittsburgh newspaper enumerated Sarah's homes, reporting that she owned residences in Pittsburgh and Daytona, a townhouse in Dawson, and a summer home at St. James Park in Dawson.

Sarah was known to entertain at home for happy occasions. For example, she hosted a party for 150 people with boating, tennis, automobiling, and fireworks on the Fourth of July in 1908. In 1912 she hosted a wedding reception for two hundred people at her home. But she was also involved when tragedy struck others. Perhaps this illustrated people's faith in her, her ability to handle a crisis, or her connections. An example came after the 1912 marriage of her nephew, Lucien Smith, to Eloise Hughes, the daughter of West Virginia Congressman James A. Hughes. After honeymooning abroad, the newlyweds planned to return on the *Titanic*.

When the ship sank, newspapers in Pennsylvania

111 "Palatial Home Planned," *Daytona Gazette-News*, April 11, 1908, 3.

and West Virginia printed updates on the status. As in any crisis, these bulletins changed as more news became available, and information seemed slow to arrive. Amid conflicting reports at an incredibly historical moment, Sarah reportedly set off for New York City to meet the *Carpathia* on the morning of April 16th. Exactly why she was involved wasn't described, but she certainly seemed to be a point of contact. On that same day, a Pittsburgh newspaper reported that she received a cablegram confirming that the newlyweds were passengers on the ship, while Connellsville's *Daily Courier* reported that the White Star Line had informed Sarah that Lucien was saved.

Ultimately no one saw Lucien again. According to newspaper accounts, Eloise last saw him when he kissed her goodbye and put her on a lifeboat as, they believed, a formality. Several years later, a newspaper reflecting on the disaster reported that Eloise had been in a lifeboat with Mrs. John Jacob Astor when she watched the ship's demise. The fact that men died so some women could access lifeboats would be later used in some anti-suffrage arguments. But despite her proximity to the tragedy, Sarah Cochran would be known publicly as a committed supporter of suffrage at the time of Pennsylvania's referendum in 1915.

Relationships of a genuine nature continued to

matter to Sarah, even as her social rank and wealth grew. In 1909 Ella Skiff visited Sarah's home outside of Dawson, at St. James Park, and wrote a letter to the *Evening Republican* in Meadville. Meadville readers might have been curious about Allegheny College's new trustee who had built Cochran Hall at the college the previous year. "She chooses [friends] for some trait of congeniality or worth, which she detects in them, rather than for some claim to family title or social distinction of which they may be able to boast," Skiff said.[112]

Skiff also remarked on the produce from Sarah's onsite orchard, "a share of whose products finds its way every year into many a Dawson home." It was just one example of Sarah's generosity. Another example was publicized by the *Pittsburgh Post-Gazette*. When World War I closed European opera houses and Eleanore Miller Cochran returned from Gdansk in 1915, the operatic soprano was called a protege of Sarah's. This might be interpreted as an example of the people who were quietly touched by Sarah's philanthropy.

As the Coal Queen, perhaps Sarah realized early on that even if she stayed involved in business on some level, her agency would be limited. Perhaps because she had never expected to be the Coal Queen in the first place, her identity didn't depend on her

112 Ella Skiff, "Summer Home Looks Like a Fairyland," *Evening Republican* (Meadville, PA), June 1, 1909, 6.

business role, and at the same time she might have realized that philanthropy would be less confining than the coal and coke industries. While she would stay involved in her businesses, philanthropy might have seemed to be the gateway to effecting change and helping people, just as a doctor had recommended after James' death.

Educational Philanthropist

If we are what survives us, then one of the important things that survived Sarah was a legacy of education. This kind of philanthropic investment was nearly the definition of generativity: Not only did the investment create intended opportunities for individuals, but it might have changed expectations for several generations afterward. For example, a person who went to college because of Sarah's generosity might then expect their own children to attend college years later, and so on. Beyond simple generosity and kindness, in some cases Sarah's educational philanthropy helped to transfer power from herself to individuals in the communities she sought to help. In some cases, her investments were made quietly for individuals, and in others they were more public and for the benefit of larger groups.

Studies in the twenty-first century have suggested that economies get stronger when women are empowered because women tend to be strong savers and often "spend more of their earned income" on needs such as food and education.[113] Along similar lines, Sarah's inclination to empower both men and women through educational philanthropy might have helped to strengthen local economies as college education became necessary for professional advancement and jobs offering higher income. Considering Sarah's own limited education, her willingness to help others earn degrees that she didn't have also suggests something about her lack of ego and the value that she placed on education, especially in rural areas. A few examples of Sarah's educational philanthropy from Pennsylvania, West Virginia, and Ohio provide a better sense of the scope of her work.

Quiet and Unassuming

In the absence of information about Sarah's less public philanthropy, Henrietta Sproat Stillwagon provides an interesting case study of one of the local people who went to college with Sarah Cochran's funding. Henrietta's grandfather, Henry Herbert, was Sarah's maternal uncle, and Sarah might have been aware of Henrietta through family connections.

113 Sharma and Keefe, "A Solution For a Struggling Global Economy: Gender Equality," forbes.com, October 14, 2011, forbes.com/forbeswomanfiles.

Like Sarah, Henrietta was born in Fayette County in a large family and might not have been encouraged to pursue higher education. From 1917 to 1919 she attended Pennsylvania State Normal School at Indiana, Pennsylvania. She played guard on the basketball team when it won the 1919 Championship of Western Pennsylvania and Eastern Ohio, was involved in clubs, and quoted Dante in her 1919 *Instano* yearbook.[114]

Henrietta's copy of that 1918-1919 yearbook and several college photos survived past her death in the late 1970s. A few basketball team photos showed her in her uniform the same year that basketball was called "one of the most popular games in which the fair sex participate."[115] Another photo showed Henrietta with three other young women in a dorm room with the words "Our room, Indian[a] Normal School" in her handwriting. One woman is reading. Another is playing music while the others look on. Everyone looks happy, and the room looks cozy with flowers in a vase on the radiator, throw pillows emblazoned with "Indiana," and personal photos and pennants around the room. More importantly, the photo shows camaraderie among young women

114 Pennsylvania State Normal School, Indiana, Pennsylvania. *Instano 1919*, 61 and 147.

115 "Basketball Game Between Women as Curtain-Raiser for Eastern Smoke Fund," *Evening Public Ledger* (Philadelphia, PA), December 1, 1917, 15.

who have gone away for the first time and are creating their own expectations for life.

By modern standards, Henrietta's career was exceptionally short: she taught for two years in the Dawson Public School. Often teaching careers in that era ended at the time of marriage, which was the case for Henrietta. The fact that Sarah funded education for teachers who might teach only a few years speaks volumes about the value she placed on education. The February 1907 issue of the *Association of Collegiate Alumnae Magazine* argued that "the securing of better trained teachers represents the most serious problem in education."[116] While female teachers weren't common in private schools at that time, the article stated that 75 percent of American public school teachers were women, and they were viewed as preparing students for college and for "the business life of the world." By the time Henrietta Sproat was in college, Pennsylvania's eighteen public normal schools educated 6,010 female students and 1,406 male students during the 1918 school year alone.[117] Sarah's funding of a teacher's education suggests her support of rural education.

116 "Women in Collegiate Administration," *Association of Collegiate Alumnae Magazine*, 3:14, 43.

117 "Education — No. 77 — Public and Private Normal Schools, School Year 1918," U.S. Census Bureau, *Statistical Abstract of the United States 1919,* 109.

Henrietta Sproat Stillwagon (seated at left window),
Pennsylvania State Normal School, Indiana, Pennsylvania
circa 1919. Image from the author's collection.

It might have also suggested that Sarah wanted
to create opportunities so men and women could
improve and support themselves, whether that was
for a brief career or the rest of their lives. At the time,
that viewpoint might have seemed like a progressive
outlook on women's education and empowerment.
Both education and the vote were sometimes viewed
as the key rights women needed to fend for themselves
in the world. Sarah's educational philanthropy might
also suggest her stance on Dr. Edward Hammond
Clark and his influential opinions, which had been
publicized in the nineteenth century. In his 1873 book
Sex in Education, or, a Fair Chance for Girls, he argued
that education could be too taxing on young women's
reproductive systems. Some organizations were said to
have spent years refuting his claims. Perhaps Sarah's
philanthropic support of women's education could be
interpreted as a part of this larger refutation.

If anyone was worried about a college education's

effect on marriage and child-bearing prospects, it wasn't Sarah or Henrietta. It also wasn't Harry Stillwagon, who married Henrietta in 1921 and had three children with her. Coincidentally and unbeknownst to them, Harry happened to be a descendant of Peter and Elizabeth Stillwagon, whose experiences with plunder and capture during the American Revolution didn't happen far from where Henrietta's ancestor, Thomas Herbert, served in Monmouth County, New Jersey. Harry was nearly three years younger than Henrietta and hadn't attended college, so in some ways the pair didn't fit the era's conventional expectations for couples. But in the snapshots from their fiftieth anniversary party in 1971, they still looked as happy as two people who just got married. The local newspaper announcement of the anniversary indicated that their grandson had a doctorate, which leads one to wonder if that would have been the case without Sarah's investment in Henrietta's education.

Henrietta was not the only person for whom Sarah financed education. It was known that she paid for local men and women to attend college if they showed promise. A *Pittsburgh Press* article from 1908 portrayed Sarah as a Lady Bountiful who was known to quietly bestow financial gifts on churches and members of the community, but generally speaking, there isn't a good way to measure the monetary scope

Henrietta Sproat Stillwagon circa 1918. Image from the
author's collection.

of her person-to-person philanthropy or to list the
names of people who received it. "Mrs. Cochran has
educated many students at her own expense, but it
has been done in a quiet and unassuming way, for she
prefers never to speak of her many acts of generosity,

always trying to prevent the right hand from know-ing what the left hand is doing," wrote Margaret Snyder.[118] When Sarah died, *The Pittsburgh Press* valued this segment of her philanthropic activity at several hundred thousand dollars (1936 dollars).[119]

Although "quiet and unassuming" investments present a roadblock for research on her philanthropy, Sarah might have had a practical reason for this method. Working under the radar would have allowed her to be involved directly on her own terms with the individuals she deemed deserving. It also would have left little room for detractors and those who felt enti-tled to handouts. For some philanthropists of Sarah's era, it could be very time consuming just to manage all of the correspondence from individuals who requested money for both worthy and questionable purposes.

Public Philanthropy

The more public component of Sarah's educa-tional philanthropy ran the gamut from donations of money to buildings to an endowed chair, all part of public philanthropy reportedly valued at $2,000,000 by the time she died (1936 dollars).[120] Occasionally she even put her own name on a large donation. For

118 Margaret Snyder, "A Noted Woman Philanthropist," *Pittsburgh Daily Post,* July 19, 1908, 26.

119 "Taken by Death," *Pittsburgh Press,* November 1, 1936, 7.

120 "Taken by Death," *Pittsburgh Press,* November 1, 1936, 7.

example, at Bethany College, where M.M. Cochran was a trustee and significant benefactor, Sarah was recorded as donating $25,000 for a Sarah B. Cochran Chair of Philosophy.[121] Through college and fraternity records, journals of academia, and other publicly viewable documents, a convenient paper trail through this area of Sarah's philanthropy has survived. In the end, it provides another lens for viewing Sarah's priorities and her generativity in middle and later life.

It also makes sense to consider her public, educational philanthropy in the larger context of American women's philanthropy. By the time Sarah was widowed, American women already had a history of being very involved in large and small philanthropic activities. While the creation of power and wealth was considered part of the masculine realm, distributing money for the greater good was considered feminine. Along those lines, philanthropic activity and business ownership seemed to develop a dual perception of Sarah's work. In a traditional sense, she could be portrayed as a philanthropic widow whose work was funded with money that originated in her husband's businesses. In a more modern sense, she could be portrayed as

121 "Endowment of Office and Chair of the President of Bethany College," *Bethany College Bulletin*, 14, https://archive.org/stream/cataloguewithc2122beth/cataloguewithc2122beth_djvu.txt.

both a business owner and philanthropist, which implied that her own business decisions continued to create wealth that funded her philanthropy. At any given time, her work and accountability could be associated only with philanthropy or with both business and philanthropy depending on the organization or publication that told a story about her.

Typically, philanthropy allowed women a socially acceptable form of power for participating in and influencing society before they could fully participate in professions or politics. If they became involved in philanthropic organizations they could assume leadership roles and develop experience that might have otherwise remained unavailable. In Sarah's case, philanthropy might have offered a place for making meaningful change as well as a better fit than the opportunities she found in the coal and coke industries.

Around the time of Philip's and James Cochran's deaths, the field of philanthropy was changing. It began to include foundations that tried to address the roots of social problems. For example, M. Olivia Sage developed the Russell Sage Foundation and Andrew Carnegie developed a foundation in his name. However, Sarah doesn't seem to have established a foundation in her own or anyone else's name. She also didn't appear to be interested in using her money with an agenda to associate prestige with her

name, clean up someone else's reputation, or make herself widely known. For example, some wealthy women of Sarah's era supported women's suffrage but still funded prestigious, all-male colleges because of the associated status, and in some cases, philanthropic activity could be used as a public relations campaign. Sarah seemed to take a different tack. Her philanthropic investments appeared genuine. The relationships they involved were sustained over her lifetime, and they reflected her love for her family, religion, education, and her concern for women. Perhaps because she gave money where she found meaning and saw a need, many of her philanthropic investments and name recognition usually stayed concentrated in a specific geographic region. In the end, this is one reason her story remained more local than those of some of her contemporaries.

Fraternity

Some wealthy women were known to champion the cause of kindergartens or orphanages in a way that fused traditional maternal roles with generativity and women's leadership. But maternal roles don't end when children grow up, and Sarah's mix of motherhood, generativity, and women's leadership took the form of a lifelong relationship with the Phi Kappa Psi fraternity. Her son had pledged the Pennsylvania Iota Chapter at the University of

Pennsylvania, and perhaps she saw him in Phi Kappa Psi members or felt like they were family. In a reflection of generativity, maybe the fraternity represented a way to get involved with the future generation in her own child's absence. This could have been an opportunity to mentor or continue the types of conversations that she and James might have had about business, career plans, and aspirations for the future.

Her relationship with the fraternity was even reflected in her home, Linden Hall, with a Phi Psi Room. Painted in the fraternity's colors, the room was always kept open for any visitor from Phi Kappa Psi.[122] But Sarah's support wasn't simply as a booster. As a benefactor, she contributed funds to improve the members' standard of living through better housing. Without really intending to, she might have even thrown down a bit of a gauntlet. Reacting to her financial support, the *Caduceus of Kappa Sigma* asked, "Could it be possible that Andrew Carnegie will open up a line of chapter houses?"[123] In 1905, *The Kappa Alpha Journal* recorded her $9,000 donation toward the Pennsylvania Iota Chapter's new house, of which $2,600 was dedicated to a memorial room for her son.[124] During 1907 Commencement Weekend at Allegheny College, the cornerstone

122 Mary Kate O'Bryon, "Beautiful Linden Hall's Influence for Votes for Women," *Pittsburgh Post-Gazette,* July 25, 1915, 35.

123 *Caduceus of Kappa Sigma,* 19, no. 5, 588.

124 *The Kappa Alpha Journal,* 22, no. 5, 687-688.

of Phi Kappa Psi's chapter house at Allegheny was laid, thanks in part to funds from Sarah. It was even recorded in the college's history as the first fraternity house to be built on The Hill for use as a fraternity house.[125] At West Virginia University, when the West Virginia Alpha Chapter needed its own house, she purchased an existing house at 480 Spruce Street in Morgantown. Chapter history recorded her attendance at its formal dedication in April 1903, and she even took some of the members on an excursion to Pittsburgh to buy oak furniture for the reception hall and two 9x12' Oriental rugs. An oil painting of Sarah's son kept his memory alive in the house, which was named for him, while she stayed financially involved when the house needed repairs and expansion. After Sarah died, the chapter bought a new house and named it the Sarah B. Cochran House.

How many fraternity houses are named for women? It is an interesting question to consider. Even in the twenty-first century it seems unusual. When we scan the built environment to identify the women in it, we consider whether their names appear at all, alone or with those of their husbands. Today we tally the number of statues of real-life women that stand in communities, not characters from fiction or the personification of virtues, or how many streets are

125 Smith, 295.

named for women. Looking back at the 1930s from the twenty-first century, we can say that these men were not just appreciative but ahead of their time in naming their chapter house for a woman.

The relationship between Sarah and the West Virginia Alpha Chapter wasn't limited to the built environment. Sarah became a maternal figure to the chapter, once called "the real mother of this chapter."[126] Every year at Mother's Day, the chapter sent her flowers. A Sarah B. Cochran Club even began as a way for student and alumni members' mothers to get involved. Over a period of years, Sarah hosted dinners for the chapter members in her own home, and these were described in newspaper articles and in fraternity publications. Years later, the chapter history book included members' recollections of visits to Linden Hall. Recalling parties there in the 1910s, some of the members were impressed by how well Sarah understood young men's appetites for food and how one member was charmed by a young woman who played music for them. On a day in 1920, Linden Hall was the location for a chapter party with afternoon activities, then dinner, kitchen snacks, and pipe organ music in the Great Hall.

The chapter members clearly appreciated Sarah's involvement with the fraternity. At an Alpha banquet,

126 Woodrum, 30.

mention of her name was said to have received a five-minute standing ovation.[127] Regardless of how long the standing ovation lasted, Sarah probably benefited from her involvement with the fraternity. Engagement with others during midlife and later years certainly is credited in improving health and making people feel vital and appreciated. Perhaps Sarah felt joyful, current, or youthful by staying involved with young people who could share her son in common with her. When she attended the fraternity's 1906 Grand Arch Council in Washington, D.C., the fraternity journal, *The Shield,* observed that the forty-nine-year-old woman "seemed as much at home during the Council as the most enthusiastic Phi Psi."[128] Conventional expectations might have deemed a fraternity banquet an unusual place for a middle-aged widow to be, but Sarah was actually not so unique. When 500 Phi Psis gathered for the fraternity's biennial convention in 1916, Sarah and the widows of the fraternity's founder and hymn writer were among the honored guests.[129] Sarah's enthusiasm for the fraternity didn't seem to wane; she owned a Phi Kappa Psi pin and ring until she died.

127 *The Shield,* 3, no. 3, 245.

128 "The Grand Arch Council." *The Shield,* 26, no. 6, 550.

129 "President Sends Message," *Evening Star* (Washington, D.C.), June 21, 1916, 14.

Cochran Halls — Allegheny and Otterbein

On college campuses, Sarah didn't limit her building projects to fraternity houses or men's residences. She also didn't keep her donations small. In fact, the president of Allegheny College cited Andrew Carnegie and Sarah Cochran as two of the college's greatest benefactors from about 1910 to 1920.[130] While Carnegie was obviously much wealthier and able to finance more philanthropic activity than Sarah, the comparison is worth noting because it illustrates Sarah's relative importance at institutions like Allegheny College and Otterbein University.

In the early twentieth century she became involved with Allegheny College, which was the third-oldest surviving Methodist-affiliated college in the country. Allegheny's newspaper suggested that her interest was fueled by an Allegheny alumnus who was the pastor of Dawson's Methodist church when Sarah's son died.[131] While the names in Allegheny's article and a church history don't reconcile, it's possible that a connection came about through the local church, given that its minister around 1901 was an Allegheny graduate. Originally formed as a Presbyterian school

130 "Dr. Crawford Delivers Last Baccalaureate," *Campus* (Allegheny College), June 16, 1920.

131 "Sarah B. Cochran, Friend of Allegheny, Passes Quietly Away," *Campus* (Allegheny College), November 4, 1936, 1.

in 1830, Allegheny became affiliated with the Methodist Church in the nineteenth century and was considered critical in providing education in "the West." Located about ninety miles north of Pittsburgh in Meadville, Pennsylvania, the college began admitting women in 1870 and graduated the muckraking journalist Ida Tarbell. William H. Crawford served as the College's president between 1890 and 1920 and used his tenure to improve the college's campus through a building program to create the college's "physical character." Eight new buildings were erected during that time, including some with funding from Andrew Carnegie and Sarah B. Cochran. By 1905, Andrew Carnegie's first donation to the school of $25,000 was recorded.[132] On November 28 of the same year, Sarah was present on campus for the opening of an annex to the women's dormitory, Hulings Hall. When Allegheny's newspaper, *The Campus,* covered the annex's opening, it reported that the new annex included suites for three college sororities, space for a literary society, and a two hundred-person auditorium that was intended for the YWCA. It also housed a two-story women's gymnasium that was made possible by "the liberality of Mrs. Sarah B. Cochran."[133]

Space, and especially a gymnasium, for female

132 Smith, 242.

133 Smith, 242.

students might have been significant in some places at that time as more women were attending college. For example, just four years earlier across the country, Hearst Hall was dedicated at the University of California. Phoebe Hearst included a women's gymnasium in the building because female students had been previously allowed to use the Harmon Gymnasium only at specific times during the week when men weren't using it.[134]

At some co-ed colleges in the early twentieth century, campus housing wasn't available for all of the female students. Because boarding houses weren't socially acceptable for women, off-campus housing was often limited to renting rooms from townspeople. At Allegheny, campus housing was created for women when they were admitted in 1870. However, because men were still relatively scattered among boarding houses downtown and campus housing, there was a need for better men's housing on campus. Allegheny men benefited from Sarah's contributions when she pledged $50,000 to build a commons and dormitory on campus for them. On June 19, 1907, the cornerstone of Cochran Hall was placed, and the building was formally presented on April 23, 1908, at a ceremony in the chapel. From there, *The Campus* reported, Sarah led a procession to Cochran Hall.[135] She unlocked the doors, but not to a Collegiate Gothic

134 Nickliss, 228.

135 "Cochran Hall Formally Presented," *Campus,* April 18, 1908,

structure. Although that style was being used for a number of college building projects in that era, Sarah had financed an American Renaissance-style building that was constructed from red brick and terra cotta. Perhaps to Sarah, nothing was too good for Allegheny or the memory of her son. At that time, Cochran Hall was considered the most ornate and expensive building ever built on campus with a final cost of $65,000. The architect was Edward L. Tilton of New York City, whose resume included an École des Beaux Arts education, McKim, Mead & White training, and a gold medal from the 1900 Paris Exposition for the design of Ellis Island's U.S. Immigration Station.

According to the college's history[136] and its 2007 preservation plan, Cochran Hall had dormitory housing for thirty students on its second floor with common and dining rooms on the first. In the basement, there was a YMCA, recreation area, and bowling alley.[137] Interestingly, the YMCA might have been well known in Sarah's business circles at that time.

136 Smith, 245.

137 Allegheny College Preservation Plan (2007), 151.

Cochran Hall, Allegheny College. Allegheny College
Archives, Wayne and Sally Merrick Historic Archival
Center, Pelletier Library, Allegheny College.

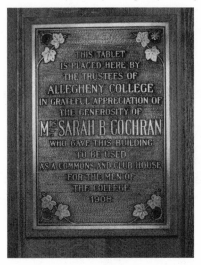

Cochran Hall dedication plaque, Allegheny College.
Allegheny College Archives, Wayne and Sally Merrick
Historic Archival Center, Pelletier Library, Allegheny
College.

The 1908 *Report of the Pennsylvania Department of Mines* reported that, as an interest in industrial education developed in mining, the YMCA was one of the institutions where coal miners and mine foremen could take night classes in the state's bituminous and anthracite regions.[138] While that might not have been how the YMCA used its space at Cochran Hall, it is an interesting overlap.

At Otterbein University in Westerville, Ohio, Sarah donated money to build another Cochran Hall, but this time it was a dormitory for 78 women. Again, her project didn't draw on the Collegiate Gothic style that was plentiful at the time. She named it in honor of her husband, who had attended Otterbein like Henry Clay Frick. Her gift of $31,000 plus $5,000 to the college's endowment was said to have been its largest gift when Henry Garst wrote its history in 1907.[139] The same history noted a proposition for a $20,000 gift from Andrew Carnegie for a library.[140] Otterbein was undoubtedly near and dear to Sarah because of its connection to Philip. While it's difficult to know if Philip espoused Otterbein's values on certain social issues, it's worth considering whether Sarah's willingness to philanthropically invest there hinted at her values. According to Garst's history of

138 Pennsylvania Department of Mines, 1908 Report of the Pennsylvania Department of Mines, 37.

139 Garst, 276-277.

140 Garst, 278.

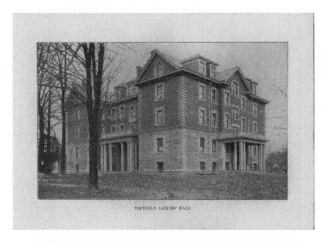

Cochran Ladies' Hall, Otterbein University. Otterbein
University, 1847-1907. Image courtesy of the Otterbein
University Archives.

the college, Otterbein employed female teachers and admitted female students at its very beginning.[141] Its board of trustees even passed a resolution in 1854 to recruit students of color. Perhaps this progressive outlook came from its founding by the Church of the United Brethren, which was anti-slavery as early as its General Conference in 1821.[142] Members of Sarah's own family appear to have been members of this denomination.

Through Sarah's philanthropic support of colleges, it's possible to see the value she placed on education, and more specifically on organizations

141 Garst, 63 and 67.

142 Garst, 122.

connected with her family and religious faith. Memorializing her husband and son seemed to be a priority in her public philanthropy, and she clearly saw value in an ongoing relationship with Phi Kappa Psi. Her mix of publicly known philanthropy and quiet and unassuming activity suggests some degree of strategic thinking behind her investments.

Trustee

S arah Cochran channeled a large portion of her philanthropic efforts into education. It isn't clear whether trusteeship was one of her philanthropic goals, but nonetheless she became a trustee of multiple colleges: Beaver College (now Arcadia University) in 1903, Allegheny College in 1908, and American University in 1915. While some specific details of this service are unknown for lack of accessible or extant documents, it's worthwhile to examine the facts of Sarah's role and trusteeship in general terms. Both provide a window into Sarah's values, accomplishments, and the historical context that she occupied.

There are a few reasons why the importance of Sarah's trusteeship can't be overstated. First, a board of trustees usually had the last word on an institution's educational and financial policies, so a trustee's influence and power over the college's vision and resources could be long-ranging and significant.

Second, a trustee's work was generally outside of the spotlight, so while trusteeship might have been a vehicle to create personal networks, it wouldn't have been a path to celebrity. Coupling that with its substantial financial commitment, trusteeship seemed to demonstrate Sarah's commitment to the greater good over her own public profile. Third, given Sarah's minimal formal education, this type of investment suggests the extent to which she believed in the value of education. Fourth, she was a trustee of co-educational institutions, generally with Methodist affiliations and sometimes local. This is important because it suggests that Sarah wasn't trying to broaden her own reputation through an association with a prestigious university that still barred female students. Instead, her work suggested that she was trying to do good according to the beliefs and causes that had meaning for her. Methodist education might have interested her solely as a service to, or influence on, her church, or it might have presented an opportunity to help enhance Methodism's position among mainstream American Protestant denominations.

Getting on Board

What was it like to be a college trustee in the first decades of the twentieth century, and why would Sarah have been selected? Without letters, diaries, or notes left over from the nominating process, Sarah's

own private thoughts and those of her nominators and fellow trustees are a bit of a dead end. However, other sources of information, such as organizations' journals and preservation plans, shed some light on the era and Sarah's experience. As a wealthy, Methodist woman with a business background, she might have been in the right place at the right time to be offered a trusteeship at these colleges.

Academia was changing in the early twentieth century. Higher education was viewed as a key to social mobility. College presidents were no longer expected to be ministers. Increasing numbers of women were attending college, even to the extent that some colleges didn't have enough housing for the women they admitted. At some colleges and universities, the dean of women became a critical role because she could help resolve female students' off-campus rental problems and act as their role model and chaperone. Another change in that era was a developing interest in efficiency, thanks in part to Frederick Winslow Taylor and his *Principles of Scientific Management*. Harvard opened the doors to the first MBA program in 1908 and was said to have incorporated Taylor's ideas in that program. In an effort to reap the benefits of efficiency, some colleges saw the business world as a source of board candidates equipped with expertise in efficiency. With that in mind, Sarah's business ownership

and service as a company director might have been viewed as a credential for trusteeship.

Amid all of these changes, the American Association of University Women (AAUW) considered the issue of college trustees in 1922.[143] It conducted its own research to find out how trustees were being selected, what their terms were, and what colleges sought when reviewing candidates. The findings help to understand the issues around the time of Sarah's trusteeship. Of the co-ed colleges that responded to the survey, only 31 percent had any female trustees at the time. Among all responding colleges, decisions about trustee selection varied, sometimes indicating that multiple methods were used at the same college or that a college might have two boards with members appointed differently. Decisions could be made by alumni/ae, a governing body or church, a governor or mayor, or the board itself. At that time, terms could last for a period of years or for a lifetime, but the AAUW's research suggested an interest in moving away from lifetime appointments. Historically, the Pittsburgh Conference of the Methodist Church could submit three names for each place on the Allegheny College Board of Trustees, and the board selected from those. With respect to terms, a history of Allegheny indicated that two men were presidents of the board for

143 "The Tenure of Office of Trustees," *Journal of the American Association of University Women*, 64-69.

sixty years, and some trustees served for more than thirty years.

The candidate's interest in the college was reported most often as a qualification for trusteeship. Others included the candidate's vision of higher education, ability, efficiency in business, character, influence, financial knowledge, and wealth. Ironically, actually having a college degree was at the bottom of the list, but that seems somewhat understandable given that college education might have been less accessible to the generation that was being considered for board roles.

One of the recommendations that came out of the AAUW's research was that colleges needed to place more female trustees on their boards. It's difficult to know how easily that could have been done given the sensibilities in some areas at that time. For example, when the Equal Franchise Society's founder, Katharine Duer Mackay, ran for the school board in Roslyn, New York in 1905, her friends were apparently taken aback that she would attend meetings with men.[144] However, this didn't appear to be a problem for Sarah Cochran, and perhaps her coal and coke industry experience helped to prepare her for this type of role. Only three years later, she became the first female trustee in Allegheny College's history, joining the board at the same time as Meadville

144 Neuman, *Gilded Suffragists*, 42.

Bishop James Thoburn, who would have recognized her from the Cochran Hall dedication.[145] Her term at Allegheny overlapped with that of Ida Tarbell, who was serving as an alumna representative to the board. In Tarbell's memoirs, she called her student years at Allegheny "the most profitable of my life."[146] By the time Sarah became an Allegheny trustee, Tarbell had already published *The History of the Standard Oil Company.*

An early twentieth-century nominating committee might have ticked many of its boxes when it reviewed Sarah's candidacy. She was wealthy, female, Methodist, a donor, and she had a business background. However, information doesn't clearly suggest whether each college recognized all or some combination of these qualifications. In March 1916 the *American University Courier* asked, "What woman more appropriately could have been added to the board than Mrs. Cochran of Dawson, Pa., whose name is found in every list of large benefactors?"[147]

One of the Guys

At American, Sarah was not the first female trustee, but for ten years she served at the same time

145 "The Catalogue Remodeled," *Campus* (Allegheny College), March 13, 1909.

146 Tarbell, *All in the Day's Work*, 47.

147 "Some of Our New Trustees," *American University Courier*, March 1916.

as William Jennings Bryan, who had joined the board a year before she did. Whether they attended the same meetings, corresponded, agreed or disagreed is unknown, but most importantly this role suggests something about Sarah's confidence. It is hard to imagine a shrinking violet accepting a board role with a man who was a former presidential nominee and secretary of state. It's worth noting that Sarah served on American's Board of Trustees at the same time as a vice president of the Pennsylvania Railroad and the editor and secretary of the National Geographic Society. Her tenure also overlapped with those of seven Methodist bishops. Beyond networking, this meant that in board meetings she was a peer to men who wielded significant power in politics, business, and religion at a time when gender limited her power elsewhere. The 19th Amendment wasn't passed until she had been on American's board for five years alongside William Jennings Bryan. Women had become eligible to be lay delegates to the Methodist General Conference only fifteen years before Sarah joined this board. Given her support of suffrage and inroads for women, could trusteeship have provided a deliberate, but limited, means of influence?

What impact did Sarah have as a trustee? In one of her early activities at Beaver College, Sarah might have created an interesting twist on a mining-industry naming tradition. Some western Pennsylvania

mines and mining facilities were named for people in the operators' families. Perhaps it seemed bizarre to name mines for women who couldn't work there when the hazards of mining were antithetical to the era's view of femininity. In the Cochrans' case, Sarah's mother-in-law was the namesake of the Clarissa Mine that James Cochran Sons & Co. owned. As a trustee of what had been Pennsylvania's "first women's college of higher education,"[148] Sarah memorialized Clarissa differently. She pledged $30,000 to endow a new Clarissa Cochran Memorial Chair of English and Philosophy and fulfilled her pledge in 1905. The chair changed department affiliations throughout its existence until 1911. In February of 1911, some of the college's outstanding loans were called unexpectedly, so Sarah allowed the college to use the chair's funds to pay off its debt.[149] But while it existed, the Beaver community saw a Cochran woman's name associated with education and the money needed to endow a chair.

A few years later at Allegheny College, Sarah made monthly chapel sermons possible during the 1911–12 academic year. Whether related to the American garden movement or President Crawford's building

148 Pennsylvania Historical & Museum Commission, "1861-1945: Era of Industrial Ascendancy," http://www.phmc.state.pa.us/portal/communities/pa-history/1861-1945.html.

149 Cameron, Curchack, and Berger, *From Female Seminary to Comprehensive University: A 150-Year History of Beaver College and Arcadia University*, 40.

campaign to create the college's physical character, she championed the college's landscape design. In 1910, she funded the bridge known as the original Rustic Bridge, as well as a sandstone wall, on a campus feature called "The Ravine." The following year, she paid for a cement walkway and a humble chain link fence on campus. By 1914, her landscape plans were getting bigger. At the suggestion of Sarah and the board president, the college made plans to plant approximately one thousand shrubs on campus. In 1912 Sarah announced a $100,000 donation to Allegheny as part of its fundraising campaign. Following that, the president was quoted in the college's newspaper as stating that Sarah "has given liberally of her money but the greatest thing she has given has been herself."[150]

In January 1921, American University's newspaper recorded her donation of a railroad car of coal, which could have been used as the university's fuel. The following year a male trustee connected with Logan Coal Company of Philadelphia donated two carloads of coal.

Sarah's trusteeships ended at various times. For financial reasons, a decision was made to move Beaver College to eastern Pennsylvania in the early 1920s, and some trustees did not stay with the college after that move. Sarah appears to have been one of those

150 "President Talks," *Campus of Allegheny*, April 27, 1912.

trustees. Whether she disagreed with the decision to move or preferred not to travel so far for meetings is not known. She was still able to travel to the South in winter but was known to have been an invalid for a number of years before her death in 1936. Her trusteeship at American University ended in 1929, but she continued to serve at Allegheny College until the year she died.

Builder

S arah Cochran was the builder of a number of
structures during the second half of her life.
From churches to dormitories to her own homes,
many building projects happened with her fund-
ing. But two stand out among the others. These
are her own home, called Linden Hall, and the
church that memorialized her husband and son, the
Philip G. Cochran Memorial Methodist Episcopal
Church.[151] Although each was architecturally signif-
icant enough to be added to the National Register
of Historic Places, these two buildings might have
been the most personal and best positioned of all her
structures to play a role beyond their architectural
significance.

151 The church was Methodist Episcopal at the time of its dedica-
tion but was later United Methodist.

Linden Hall at St. James Park

Grounds sprawl across roughly six hundred acres that compose Linden Hall at St. James Park. Perhaps the acreage that the Cochrans amassed there always felt like a serene respite, far away from the towns, mines, and railroads that were actually just a few miles away. A ribbon of a road wound past linden trees inspired by Unter den Linden in Berlin, and then up a hill to a Tudor Revival mansion that sat grandly at about a 1,300-foot elevation. The meandering road seemed to be one that was meant to allow time for visitors to absorb the landscape's natural beauty and the elegance of the crescent-shaped mansion they were about to visit. It also provided more than enough time to realize that anyone who built this mansion was not someone who was apologetic about taking up space by herself. In this case, space meant more than thirty rooms, a garage connected to the mansion via tunnel, a private basement bowling alley, and a private train station.

The mansion was not in a diminutive or typically feminine architectural style, like Queen Anne or Carpenter Gothic. It was also not dark inside to imitate a paneled men's club, boardroom, or Victorian house. It was spacious and light, an elegant and solidly built Tudor Revival that Joseph Kuntz designed. The fact that Kuntz typically designed and built industrial and commercial structures may explain

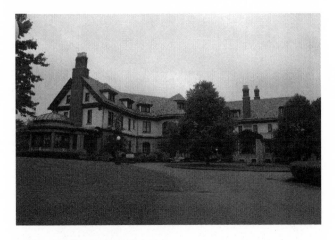

Linden Hall. Photo by author circa 2013.

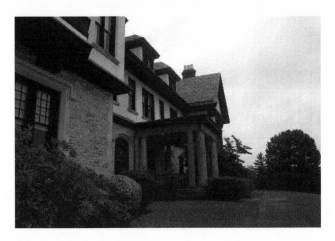

Linden Hall. Photo by author circa 2013.

why steel and other industrial building materials were part of this building's construction but not usually seen in the era's private homes. Perhaps Linden Hall reflected its owner's graciousness and hidden strength.

The private nature of people's homes is what makes them such revealing sources. By glancing around anyone's home, it's easy to see what is or isn't important to the person and where that person has been, literally or figuratively. Linden Hall was no different. Sarah's travels were represented, but she acquired a number of imported furnishings through Joseph Horne's department store in Pittsburgh. In the structure itself, she incorporated part of her monogram throughout the ceiling design of the great hall, and stained-glass images of her favorite thinkers, such as Dante, were incorporated into several small windows. In another small, stained-glass window were the words, "Life is a measure to be filled, not a cup to be drained."

Linden Hall cost $2 million to build, and stories about Sarah's interactions with people in the building process may offer insight into her character. For example, she was said to have hired sixty Italian stonemasons to work on the house. When they finished their work, at a time when immigrants might not have been accepted by everyone, she supposedly sponsored them for American citizenship. A newspaper story claimed to trace the origin of her 1916 bishops' meeting to a particular guest's suggestion during the laying of the mansion's cornerstone.[152] Oral history even suggests that she invited a number

152 Marion H. Damhman, "House Party of Thirty Bishops," *Pittsburgh Daily Post,* April 23, 1916, 16.

of people to the house's Christmas 1913 dedication, including those who had never accepted her as part of society. These stories help to support local impressions of Sarah's gracious and welcoming nature that extended to everyone, regardless of a person's origin or social status.

Decades after it was dedicated, Linden Hall was still considered spectacular, a type of estate that was unusual to find so far outside of a city. Perhaps one of the most eye-catching and unique parts of the house was its large Tiffany window that presided over the main staircase. The three-panel, stained-glass window was custom designed with dramatic proportions and color. Through a foreground of large stained-glass pine trees, the window was a view of Linden Hall's garden in full bloom, with its fountain featured at the center. The design began with a watercolor rendering that was ultimately modified; for example, trees that originally suggested Tuscany or the south of France were ultimately changed. Before it was moved to its place at Linden Hall, Sarah reportedly gave permission for Tiffany to exhibit the 22' wide by 10' tall favrile-glass window in its New York showroom. *The Brooklyn Daily Eagle* described it as a "veritable paradise of flowers" behind "rugged and gigantic pine trees."[153] Years later

153 "A Handsome Window," *Brooklyn Daily Eagle,* October 3, 1912, 3.

Northrop, Agnes F. (1857-1953). Design for window for Sarah Cochran,
Linden Hall, Dawson, Pennsylvania, ca. 1913. Maker: Tiffany Studios,
1902-32. American, Made in United States, New York. Watercolor, gouache,
and graphite on wove paper mounted on original grey matt board. Overall:
13 1/4 x 7 7/8in. (33.7 x 20cm) Other (Design): 10 x 2 1/4 in. (25.4 x 5.7
cm) Other (mat/mount size): 19 1/4 x 14 1/4 in. (48.9 x 36.2 cm). Purchase,
Walter Hoving and Julia T. Weld Gifts and Dodge Fund, 1967 (67.654.229).
Image copyright © The Metropolitan Museum of Art. Image source: Art
Resource, NY

it would be considered one of Tiffany's greatest flo-
ral windows.[154] The designer was Agnes Northrop,
a woman who was born the same year as Sarah and
who also happened to work in a very male world.
One might say that she shattered a sort of stained-
glass ceiling because she was the only woman to have
her own studio inside the Tiffany studio. By the time
she designed Sarah's window, she had already won a
Diploma of Merit for her stained glass at the 1900
Paris Exposition. Her specialty became floral designs
in ecclesiastical and secular commissions, such as a
window for the home of Walter Jennings of Standard
Oil. Just as in the Cochran Hall project at Allegheny
College, Sarah involved experts in their fields.

Linden Hall wasn't built just as Sarah's private
home. It was a place to entertain for business and
personal reasons; there was a Phi Psi room for visit-
ing fraternity colleagues, and it has even been said
that royalty, financial titans, and political giants were
entertained there. The public rooms must have been
consciously designed for entertaining. Off the Great
Hall was a particular room with a small balcony or
patio where men were said to have aired out after
smoking or having a drink. Having been influenced by

154 Frelinghuysen, Alice Cooney, "The Garden as a Picture:
 Agnes Northrop's Stained-Glass Designs for Louis C.
 Tiffany," filmed September 27, 2016 at Smithsonian,
 video, 1:12:52, https://americanart.si.edu/blog-post/305/
 glass-gardens-agnes-northrop-designs-for-louis-c-tiffany.

nineteenth- and early twentieth-century Methodist churches in southwestern Pennsylvania, Sarah might not have seen alcohol in the most favorable light. Could the room have telegraphed Sarah's views on smoking and drinking while accommodating the norms of the day for acquaintances with different social beliefs?

Only a few years after Linden Hall's construction, Sarah sold her Pittsburgh and Florida homes that had been the talk of Pittsburgh newspapers a decade earlier. However, Sarah's private real estate still inspired curiosity. Linden Hall generated nearly a full newspaper page of photographs and text when she hosted a public suffrage rally there in 1915. The following year it made headlines throughout the country as the first private home to host the Methodist Episcopal bishops' semi-annual meeting. Sarah's home was not just associated with her personal entertaining; it could be used as a vehicle for advancing certain personal causes.

Church Builder

Fayette County's built environment benefited from Sarah's ventures beyond Linden Hall. Over the course of thirty years, she was the builder of Methodist and United Brethren churches, and what began with her husband on a small scale increased in financial size and architectural grandeur after she was

widowed. When she worked on her own, her building projects memorialized her immediate family and, like her academic and residential building projects, often demonstrated that no expense had been spared. It's worth examining her history of church building and her last known and greatest church project, the Philip G. Cochran Memorial Methodist Episcopal Church. In this case, it's also helpful to have some information about Methodism in Sarah's era.

As a Protestant denomination in the United States, Methodism grew robustly from its 65,181 members in 1800,[155] when it was a fairly new sect, to 4,226,327 members in 1900 and 8,346,004 just four years after Sarah Cochran's death.[156] In 1850, one in fifteen Americans had a Methodist affiliation,[157] and as the nineteenth century went on, the church was becoming increasingly interested in being involved with higher education.

Methodism arrived in western Pennsylvania in the 1780s when Methodists migrated from Baltimore and spurred development of the Redstone Circuit. At that time, members met in log chapels or their own homes. Bishop Francis Asbury traveled to

155 "United Methodist Membership Statistics," http://gcah.org/history/united-methodist-membership-statistics. This does not include Evangelical United Brethren statistics.

156 "United Methodist Membership Statistics," http://gcah.org/history/united-methodist-membership-statistics. This does not include Evangelical United Brethren statistics.

157 Robins, 165.

western Pennsylvania twenty times between 1784 and 1815 to help shepherd the denomination's growth, and the area's first District Conference took place at Uniontown in 1788. In 1825, the Pittsburgh Conference was established. The denomination swept through the region during the nineteenth century; camp meetings, a number of newly built churches, and Allegheny College's Methodist affiliation were evidence of this. Western Virginia, Erie, and Eastern Ohio had to develop their own conferences between 1848 and 1876 to accommodate the region's growing church membership. In northwestern Pennsylvania, Ida Tarbell's parents happened to leave the Presbyterian Church to join the Methodist Church, and Tarbell recalled that she didn't dance because "the Methodist discipline forbade it."[158] Methodism was mainstream by the time Sarah was becoming involved in church building projects, and its members were far from frontiersmen in log chapels and camp meetings.

Before Sarah was widowed, the Cochrans already had some experience with church building; a small, local church project was made possible by Little Jim Cochran. After Rev. David Flanagan organized a Methodist Sunday School and Society nearby in the town of Vanderbilt in 1888, Little Jim donated $1,000 to build the Cochran Chapel there. It was

158 Tarbell, 46.

renamed the James Cochran Memorial Church after he died.

In Star Junction, Sarah may have been involved with Philip in building a Methodist church, but her involvement is portrayed differently in different sources. Originally organized with seven members by Rev. W.S. Cummings of Perryopolis, the church's foundation was laid on October 5, 1897, and the church was dedicated on January 16, 1898.[159] Early twentieth-century newspaper coverage and Guy Smeltzer's 1969 Methodist history credit Philip Cochran with suggesting and funding the project in his capacity as Washington Coal and Coke Company's president. It wasn't unusual for mine owners to provide land or funds for churches in their company towns; however, the extent of that assistance could depend on the denomination and whether the employees were affiliated with an American church or a church overseas. However, later twentieth-century sources attribute the church to the couple.[160] It's difficult to confirm whether Sarah was actually involved at the start or if she became involved only as a Washington director and large stockholder after Philip's death. For the church's twenty-fifth anniversary celebration in 1923, Connellsville's *Daily Courier* credited Sarah with financing the parsonage,

159 Smeltzer, *Methodism in Western Pennsylvania*, 882.

160 Mulrooney, *A Legacy of Coal: The Coal Company Towns of Southwestern Pennsylvania*, 46.

auditorium, and Sunday School classrooms between 1898 and 1909, but it did not associate her with the company that owned the town. It did, however, point out her late husband's affiliation with both the company and church founding.[161] This could be an indicator of their true roles or of the public perception of which gender to associate with business or religion.

After Philip's death, Sarah decided to build a church in his memory in the town of Dawson, where they and Philip's parents had lived. Methodism had arrived in the vicinity of Dawson around 1820, but it came to town in the shape of a wood-frame church in 1872 with an official pastor in 1873. In 1900, Sarah had the wood-frame church dismantled and reconstructed about two miles away as the Bryan Methodist Church. *The Pittsburgh Daily Post* wrote of "great days for religion at Dawson" when it advertised that the Cincinnati bishop would dedicate the Bryan church, and the following day a cornerstone would be laid for Dawson's new Methodist church.[162] In a simple comparison of both churches' photos, the new church was much more extravagant. Its exterior was constructed of brick and included what resembled Italianate details. One of the church's windows was a Tiffany

why?

161 "25th Anniversary of Star Junction Church Next Week," *Daily Courier* (Connellsville, PA), January 10, 1923, 1.

162 "Church Dedication in Dawson," *Pittsburgh Daily Post,* July 15, 1900, 9.

design depicting Jesus standing with a shepherd's crook in one hand and a lamb in the other.

A few years later, Sarah gave the church a new pipe organ and built a new brick parsonage. In 1905, when she returned from Dresden with L. Sturm's copy of *The Sistine Madonna,* she presented it to the congregation and had it installed in the church. Given her experience in nineteenth-century United Brethren and Methodist traditions, would it have seemed unusual or too Catholic to have a large, Renaissance depiction of Mary in a Methodist church? It probably was unusual for a Methodist church in one of western Pennsylvania's railroad towns. Perhaps, like Jane Stanford, Sarah understood that locals weren't going to visit Europe to see original Renaissance masterworks, so this was an opportunity for them to experience great art and call it their own. After a local newspaper called out Andrew Carnegie's failure to purchase this particular painting, it might have felt like a special treasure on multiple levels. Regardless of everything else, it might have resonated with Sarah and members of the congregation: at its center was a woman from humble beginnings, thrust into a life she hadn't expected, who lost her son too soon and became an icon of maternal love and wisdom. A woman's place in religion, politics, and business might have been debated, but no one questioned the authority that accompanied motherhood.

The new brick church, with over 250 members, reflected the prosperity and energy that the coal and coke industry had injected into the region since the previous structure was built. In Dawson, the 1890s brought an opera house, a volunteer fire company, and a water system to this town that wasn't quite thirty years old yet. It would be a few years before the town's borough building would be constructed. At Sarah's brick church, the Tiffany window made a statement about both Methodism's and Dawson's place in the world, given that Tiffany's stained-glass windows were in vogue for houses of worship around the country. Sturm's copy of *The Sistine Madonna* did the same thing. It was a far cry from the log buildings where western Pennsylvania Methodists had worshiped a little more than 100 years before, and perhaps people realized that. Dawson and its Methodists had arrived.

In 1902, Sarah built a church in memory of her own parents near the area where they had spent their early lives. Called the James F. and Sarah Herbert Moore Church in a *Religious Telescope* article, this United Brethren church was brick veneer and visible from a distance around Chestnut Ridge in Fayette County. W. R. Funk, who said he had delivered the funeral address for Sarah's mother, wrote the flattering *Telescope* article about the church's dedication

in April 1902.[163] "The house is a splendid structure, with four gables and a corner tower. The windows are cathedral, with opalescent glass. The pews are of oak, and circular," he wrote. Sarah reportedly paid $3,350 of the church's $4,000 total cost and attended the dedication with two of her sisters. Their uncle, Richard Herbert, also attended. At seventy-two, he was a lifelong United Brethren and might have been the same Richard Herbert who was a trustee of the church.

In 1922, Sarah wanted to revisit the Methodist church structure in Dawson and present the congregation with Thomas Pringle's grand design. Unlike the academic buildings she had financed during Collegiate Gothic's prolific era, this project would be in the Gothic Revival style. Stained-glass windows would be designed and made by none other than Henry Hunt in Pittsburgh. The building's construction took about five years, and, according to the church's written history, Sarah assisted J.L. Hull, the construction superintendent, in laying the structure's cornerstone on May 1, 1927. The District Superintendent, H. N. Cameron, and Dr. Hicks of McKeesport delivered addresses. M.E. Strawn, representing the church-building committee, presented a cornerstone box that contained items like photographs of Philip, James, and Sarah, as well as the architect's business card and some religious texts.

163 W.R. Funk, "The James F. and Sarah Herbert Moore Church," *Religious Telescope*, April 30, 1902, 18.

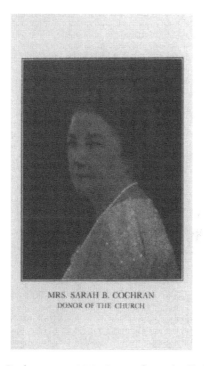

MRS. SARAH B. COCHRAN
DONOR OF THE CHURCH

Sarah B. Cochran circa 1927. Image from the Philip G.
Cochran Memorial Methodist Episcopal Church Dedication
Services program, deposited with the United Methodist
Archives Center, Madison, New Jersey.

Sarah financed the $325,000 project herself, which
required the purchase of extra land and relocation of
the parsonage to make room for the immense struc-
ture. The brick church's pipe organ was given to
Dawson's Catholic church, Sacred Heart, in 1925;
both the Tiffany window depicting Christ and the
Sturm copy of *The Sistine Madonna* were stored

and then moved to the new church when it was completed.

During the week of Thanksgiving 1927, dedication services took place from November 20 through 27. Beyond the dedication itself, the week's festivities included a homecoming for former ministers and a Thanksgiving holiday service. During the November 20 morning dedication service, Bishop Francis McConnell of the Pittsburgh Area delivered a sermon. Eleven years earlier, he had attended the bishops' meeting at Linden Hall as Denver's bishop. That evening, Bishop John W. Hamilton of Washington, D.C., delivered a sermon. He, too, had attended the Linden Hall meeting when he was Boston's bishop. The following Sunday, Sarah's brother-in-law, Dr. W.J. Lowstuter, delivered a sermon as part of the morning worship, and Allegheny College's president, Dr. James A. Beebe, gave a sermon at evening services. Lowstuter had been on the trip to Dresden over twenty years earlier when Sarah bought *The Sistine Madonna,* and now he was a professor at the Boston School of Theology. Beebe might have known Sarah through her ongoing service as an Allegheny trustee.

The Philip G. Cochran Memorial Methodist Episcopal Church was officially open for worship. On some level, this structure that resembled a four-teenth-century British parish church was probably

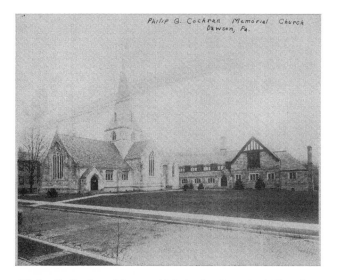

Philip G. Cochran Memorial Methodist Episcopal Church.
Courtesy of the Commission on Archives and History of the
Western Pennsylvania Annual Conference of The United
Methodist Church. Image used with permission of the trust-
ees of the Philip G. Cochran Memorial United Methodist
Church.

an unexpected find in Dawson. Perhaps it appeared
as if an enormous tornado in England had lifted up
an entire church and dropped it, intact, among the
nineteenth-century houses. From the outside, the
single structure of Beaver and Indiana County lime-
stone might have seemed enormous as it housed the
sanctuary, social hall, kitchen, and Sunday school
classrooms. At the top of the sanctuary's crossing
tower, a 105-foot steeple presided over the structure's
slate roof. On the sanctuary's western wall, Henry

Hunt's large stained-glass window depicted Christ's resurrection, and below it an inscription in the stone wall read, "Erected by Mrs. Sarah B. Cochran and dedicated to the glory of God in memory of her beloved husband and son." Hunt had also produced smaller stained-glass windows that were part of the sanctuary's northern and southern walls.

Just outside the sanctuary, the brick church's Tiffany window of Christ was set into an exterior wall by a stairwell. The choice of placement is interesting given that the church was noted for adhering to Ralph Adams Cram's design principles. Cram was known as a traditionalist in church design and produced Gothic Revival chapels for West Point and Princeton University. About twenty years earlier, he had taken issue with plans to install Tiffany's Russell Sage Memorial Window in a church that he had designed.[164] At the turn of the century, Tiffany windows might have been in demand, but they weren't necessarily part of true Gothic church style. Years later, the Cochran church would be considered an important example of High Gothic Revival architecture, and perhaps the placement of the Tiffany supported that.

The Cochran church must have been stunning when the doors first opened to churchgoers, particularly those who were familiar with western

164 Duncan, Eidelberg and Harris, 136-137.

Pennsylvania's wooden churches. Entering the cruciform sanctuary through the northern or southern narthex door, visitors might have been struck by the vaulted ceilings and large stone piers. Looking past the wooden pews, they would have seen the altar that stood under the steeple. They might have noticed the sounds of their steps as they walked along the nave or aisles that were paved with small, handmade square tiles decorated with tiny crosses. If they looked toward the choir and pipe organ, they would have met the gazes of Mary, Jesus, and Raphael's cherubs from *The Sistine Madonna* canvas. The pipe organ had been designed specifically for this church by Hartford's Austin Organ Company, and its notes might have resonated powerfully through the wooden pews and high ceiling of the sanctuary.

The church's architecture could have transported the congregation away from their ordinary lives for service and Sunday school. It would have visually signaled Methodism's mainstream position as little could be more aligned with the Western religious establishment than medieval architecture and the *Sistine Madonna*. It would have also signaled the prosperity of the town; Dawson was said to have had a millionaire on every corner because of the wealth that grew out of the coal and coke industries.

A Unique Impact

The built environment can signal important information such as longevity, affluence, access, and traditions. Sarah's increasingly grand church projects in Dawson ultimately represented Methodism, and her own congregation in particular, as part of the establishment rather than as a new or fringe denomination. Ultimately, her 1927 structure visibly replaced any association anyone might have still made with log chapels and camp meetings. Methodism in Dawson was visibly part of a much longer Christian tradition.

Any building project makes a statement. Sarah's home and church made strong, confident statements about the legitimate positions that she saw herself and her congregation, or Methodism in general, occupying. Because her private space and the sacred space were so extravagant for the area, they naturally generated reactions. When needed, these could channel support for causes that Sarah supported in ways that might not have worked had the buildings been designed on a smaller scale.

Activist and
Influencer

In the summer of 1915 and spring of 1916, Sarah's
home became a means to lend a public voice to
two of her causes. Her activism and influence sug-
gested an interest in shaping the future as she hosted a
large women's suffrage rally on her property, and then
she distinguished the mansion—and herself—when
Linden Hall was billed as the first private residence
to host the Methodist Episcopal Church bishops'
semi-annual meeting. These events for activists and
"angels" could be interpreted as great examples of
Sarah's generativity, and both are especially inter-
esting because they involved Sarah's home, her most
personal and private place, and the place most closely
associated with women. In the suffrage rally's case,
opening her home might have been a way to increase
attendance and media attention, and the setting for a

gracious brand of activism might have been used as a statement about the cause.

Sacred Rights

There was supposed to be a storm in Fayette County on July 29, 1915, but about five hundred to six hundred people paid a dollar per ticket to visit Linden Hall anyway. Most had probably never been to the mansion, and curiosity about the six-hundred-acre estate and the grand house probably drew a few who would have been called nosy, or "nebby" in western Pennsylvania's vernacular. But the woman suffrage rally was the reason people journeyed on trains, trolleys, and cars despite the weather. "All are welcome," was how it was advertised in newspapers. The Dawson Suffrage Association even ran jitneys to Linden Hall to make the event accessible. Pennsylvania was going to have a woman suffrage referendum later in the year, so suffrage events were happening all over the state to raise money and win the hearts and minds of male voters.

Why was Sarah, of all people, hosting a suffrage rally? When Sarah's appointment as an American University trustee was announced earlier that month, her activism was half of the headline. It read, "Dawson (Pa.) Woman Honored by American University; Is Ardent Suffragist."[165] Perhaps the headline was

165 "Dawson (Pa.) Woman Honored," *Pittsburgh Post-Gazette,* July 16, 1915, 5.

another way to advertise who was aligned with suffrage. According to the article, she had been involved with the movement since the woman suffrage party came to Fayette County, but it's not clear whether that was just when she began to show public support for a cause she had already embraced privately or was the first time she ever supported suffrage.

Although no explanation was given, speculation about her support can be made based on what's known about Sarah and the era. As a well-traveled leader and a peer to high-powered men, she might have questioned her disenfranchisement. Perhaps her work in a male-dominated industry was her proof that women were entitled to the vote, and as a business owner she might have wanted the same voice in public policy that her male employees had. It's possible that her philanthropic activity showed that even influence endowed by wealth was limited by gender. Without the basic power and citizenship rights that men had, her influence would always be confined to specific realms. While some anti-suffragists contended that the family unit should trust the man of the house to cast ballots, perhaps as a widow Sarah was keenly aware that women were capable of taking care of themselves.

While it's more of a stretch to say without documentation of Sarah's own thoughts, maybe she grew up believing that women deserved full citizenship

rights. It's difficult to know what she knew of her foremothers and their views, but it's possible that her great-grandmother, Alice Hill Herbert, might have voted in New Jersey or knew that other women did. During a window of years, women who were single and property owners in the Garden State could vote until they were disenfranchised in the early nineteenth century. Speculation aside, it's interesting that the death of Sarah's nephew, Lucien Smith, on the *Titanic* did not stop Sarah from supporting suffrage. In some places, anti-suffragists actually used the tragedy as an argument against women's enfranchisement.

A Larger Movement

What was the nature of the suffrage movement by the time Sarah was publicly involved? Sixty-seven years earlier, and not even a decade before Sarah was born, the Seneca Falls Convention took place in upstate New York. Since then, what's been recognized as an organized American women's suffrage movement took shape and became more and more complex. The Civil War slowed that movement, and in the Reconstruction era, concerns about states' rights in the South developed and stayed with the movement. Through the Women's Christian Temperance Union, nineteenth-century temperance supporters from the

Midwest came into the suffrage fold, believing the franchise could help women control the problems of alcohol. This also activated the liquor industry against women's suffrage.

At the start of the twentieth century, the movement needed to attract the working class, and the working class needed suffrage so working women could have a say in labor laws. However, there could be an uncomfortable tension between wealthy and working-class suffragists. At the same time as populist and progressive movements helped suffrage gain steam, parts of the movement absorbed the xenophobic and racist fears of some native-born whites.

One of the factors that helped the movement regain its momentum in the early twentieth century was the involvement of well-off society women. With these women came more solvency, a fashionable reputation, and the benefit of publicity that accompanies society. Just a year before Sarah Cochran hosted her event in Dawson, Alva Vanderbilt hosted a suffrage event at Marble House and brought activism to the Newport set. During the 1910s, magazines and newspapers were said to have devoted more coverage to suffrage than ever before, and the movement was more actively marketed than in previous generations. In Pennsylvania, an example of this marketing was the Justice Bell, a replica of the Liberty Bell

that was driven to every county in the state.

Disagreements existed over strategies and tactics to win the vote, and the movement was becoming so big that—for better or worse—there was a place for every kind of suffrage supporter. The National American Woman Suffrage Association (NAWSA) continued to pursue its slow, diplomatic, state-by-state plan to enfranchise women, while Alice Paul's Congressional Union focused on a Constitutional amendment. Paul was a generation younger than Sarah Cochran and a highly educated New Jersey Quaker who had worked with the British suffragettes. She used marketing strategies, such as staging her suffrage parade in Washington, D.C. to coincide with President Wilson's inauguration. Later, some considered her group's tactics confrontational and unladylike, such as picketing at the White House during World War I or society woman Louisine Havemeyer's trying to light an effigy of President Wilson on fire with a torch that resembled that held by the Statue of Liberty. Paul's suffragists would go to prison, where they endured hunger strikes and force feedings, and then go on speaking tours to highlight their experiences. But all of that was very different from a summer day in Dawson in 1915.

Don't Make a Spectacle of Yourself

Sarah Cochran would have had options about what style of activism and tactics she favored and who needed to be won over. Considering that one of her companies used over eighty-six thousand pounds of explosives that year, she could have accessed tools for an "explosive" spectacle that could have eclipsed Louisine Havemeyer's effigy of President Wilson. But Sarah was apparently not a person who embraced PR stunts, and this event was never meant to be a fiery spectacle; instead, it was elegant and nonconfrontational. But what did activism look like in western Pennsylvania? Just two years earlier, Mrs. Frank M. Roessing, the president of the Pennsylvania Woman Suffrage Association, told *The Pittsburgh Press* that she approved of parades if suffragists participated as a division, but not when parades were exclusively for suffrage.[166] In a subtle activist display, though, publicity about Sarah's event referred to her by her own name, Mrs. Sarah Cochran, not as Mrs. Philip Cochran. At that time, this was a departure from how many suffrage supporters were named in Pittsburgh newspapers. Likewise, some high-profile American suffrage supporters, most notably Mrs. Frank Leslie and Mrs. Russell Sage, continued to associate their husbands' names and status with their activism.

Just days before the event, Sarah was quoted in Uniontown's *Morning Herald* as saying, "Those who

166 "Whole State to Be Canvassed by Suffragists," *Pittsburgh Press*, October 28, 1913, 20.

attend from Uniontown can co-operate with the business men's project of Bargain Days by visiting the stores at other hours since they are continued for two days and one afternoon from the chautauqua we sincerely hope will not interfere financially with the splendid work they are doing."[167] Less than ten years before, businessmen were considered an enemy of suffrage because some of them believed that enfranchised women would vote for pay equity that would erode their profit margins. It's possible Sarah was trying to be a good diplomat for the cause, or perhaps because of her comparatively larger wealth, she was trying to be gracious if her event took business away from local shop owners. Strategically, she invited the governors of adjoining states to the rally because they were already scheduled to gather near Uniontown at the Summit Hotel for a roads meeting.

Sarah seemed to be aligned with NAWSA's diplomatic approach, and she had been working with local suffrage organizations toward a win on the state referendum. But NAWSA's scattered—and sometimes lost—records make it difficult to prove whether she had a membership in the organization, and it's hard to know where she stood on all of its positions. For example, NAWSA was criticized for xenophobic views of immigrants around the turn of the century, but decades later Sarah was still known

167 "Committees and Aides for Suffrage Tea at Dawson," *Morning Herald* (Uniontown, PA), July 27, 1915, 8.

for bringing Italian stonemasons to work on Linden Hall and then sponsoring them for American citizenship. Along the same lines, newspapers indicated that "Everyone is welcome" at her event. Had Sarah wanted to host an exclusive event and control attendance, she could have invited specific people.

Weeks in advance, a number of people meticulously planned the event's details, from entertainment, to refreshments, to floral arrangements in suffrage colors, to girls selling suffrage souvenirs. It was its own type of carefully orchestrated marketing blitz. The usually private Linden Hall would attract public interest and align suffrage with culture. An event there could present suffragists as approachable and feminine, and in Sarah Cochran there was something for everybody. A traditionalist might have seen a devoted wife and mother who had repeatedly memorialized her late husband and son in church buildings. The working class might have noticed that she came from a working-class background but was able to navigate in cosmopolitan circles. The New Woman might have seen her as a business leader and educational philanthropist. Perhaps her humility and personality would put people at ease. Between her own life experiences and her kindness, it probably would have been hard not to be inspired by her.

Advertised as both a rally and "Mrs. Cochran's suffrage tea," this fundraiser specifically benefited

the Fayette County Woman Suffrage organization and was expected to be western Pennsylvania's largest suffrage event ahead of the referendum. Newspapers did not miss out on its coverage. The *Pittsburgh Post-Gazette* ran an almost full-page article ahead of the event, but most of its focus was on the mansion and grounds. The history of the land's ownership was even traced back to the eighteenth century, and the views from the property were described in glowing detail. The writer compared the location to the Catskills and noted the serene landscape's distance from the mining operations. Photographs of the exterior and interior were included with meticulous descriptions of public and private rooms' décor.

At the time of the rally, Dr. Anna Howard Shaw was the president of NAWSA. Coincidentally a Methodist like Sarah, she was known for being one of the suffrage movement's greatest orators. She spent several days on a speaking tour in Pennsylvania as part of her plan to deliver 120 speeches in Pennsylvania, New Jersey, New York, and Massachusetts ahead of these states' suffrage referenda. The four states were so important that Shaw refused to accept speaking fees for any of these speeches. According to her diary, her barnstorming tour took her to events in the cities of Norristown, Altoona, and Johnstown before she arrived at Somerset on July 28. There she met Mrs. E.E. Kiernan, who led suffrage efforts for Somerset,

Cambria, Blair, Huntingdon, Fayette, and Bedford Counties. Kiernan planned to accompany Shaw to Linden Hall, where Shaw would keynote the July 29 event. On July 30, Shaw left Connellsville on a 9:26am train, rumbling toward scheduled speeches in Beaver Falls and Butler.[168]

July 29, 1915

Perhaps the excitement at Linden Hall was palpable as guests arrived on July 29th. Little girls wearing white dresses and yellow suffrage sashes greeted arriving guests, whom Sarah then received. While everyone gathered on the first floor and verandas, the weather held out so a band could play on the lawn. An organ concert followed, probably showing off the Aeolian pipe organ in the mansion's Great Hall. After an opera singer finished performing an aria from *Thaïs*, Mrs. Kiernan raised a potato masher instead of a gavel to call the meeting to order. As she rapped it, she chose words to counter anti-suffrage worries in western Pennsylvania: "Even our meetings show that suffragists are domestic!"[169] It seems sad that those who opposed or wavered in their support of suffrage

168 Diary of Anna Howard Shaw, Papers of Anna Howard Shaw in the Mary Earhart Dillon Collection, 1863-1961, A-68, Series X, 389v. Schlesinger Library on the History of Women in America, Radcliffe Institute for Advanced Study. https://id.lib.harvard.edu/ead/c/sch01002c00050/catalog.

169 "Stirring Rally for Suffrage in Fayette," *Pittsburgh Post-Gazette,* July 30, 1915, 7.

had to be reassured that women with full citizenship rights would still find their way around a kitchen. It was such a concern that in the same year, the Equal Franchise Federation of Western Pennsylvania published its own suffrage cookbook as both a fundraiser and a refutation of anti-suffragists' ideas. At Linden Hall, the potato masher made a statement, but enfranchised or not, the woman known as "the chatelaine of Linden Hall" probably didn't need to do her own cooking anyway.

Next was the keynote speaker, Dr. Anna Howard Shaw. There doesn't seem to be a record of Shaw's speech from this event, and she didn't appear to reuse the same speech at every speaking engagement. Newspapers reported that she spoke with knowledge and a sense of humor for two hours. Not only did she make the political case that the country was not a republic if only half the people could vote, but she also drew on the Bible, arguing that "it is not good for man to stand alone."[170] Maybe she reviewed the western states where women could already vote, or explained why NAWSA was working on a state-by-state approach to suffrage. Would she have tailored her speech to fit the interests of people in the area's mining communities? She did explain some of the current reasons to support suffrage. At that time, some of those reasons could have been related to

170 "Open Fayette Campaign," *Pittsburgh Daily Post*, July 30, 1915, 9.

women having a voice in making laws related to child labor, women's labor, or alcohol. At its 1907 convention, NAWSA had urged federal and state governments to forbid children under sixteen from working in mines, stores, or factories. Around the same time, the Report of the Pennsylvania Bureau of Mines essentially characterized child-labor supporters as zealots and communicated the need for children to earn money early in mining communities, particularly if their fathers had died in the mines. It's hard to know if or how the child-labor argument was made in western Pennsylvania. In any case, it's possible that taxation without representation might have come up, given that the Sixteenth Amendment had just created a federal income tax in 1909, and the Seventeenth Amendment, passed in 1912, allowed voters to elect senators themselves.

A Pittsburgh newspaper quoted two points from Shaw's speech. The first reflected the developing war in Europe and the belief that female voters would naturally create a more peaceful environment. More importantly, it countered a Civil War-era idea that suffrage was related to military service. "It has been said that women should not have the ballot because they cannot fight. We want to have women participate in the government to keep men from settling disputes by fighting," she said. Shaw's next reported remark addressed common concerns but might have

seemed ironic in a community built on all-male min-
ing. "You men talk about women going to work, tak-
ing men's work from them. There are more men today
doing the work of their grandmothers than there are
women doing grandfathers' work."[171] While guests
might have worked in many industries, in reality,
Sarah might have been the only woman who actually
had taken a "man's job." At the end of Shaw's talk,
another opera singer closed the event with a perfor-
mance from *Aida*. Featuring opera singers not only
made for an elegant affair showcasing the power of
women's voices, but it also provided work for women
who couldn't perform in European opera houses
during World War I. One of these singers was consid-
ered Sarah's protege, Eleanore Miller Cochran.

Newspaper Reactions

Suffragists were using newspapers strategically
in 1915, and Sarah's event provided an opportunity
for glowing coverage of the cause in mainstream
newspapers. Newspapers spoke highly of the event
and included descriptions of the mansion, such
as the Adam dining room and Chinese breakfast
room, where refreshments had been served. Readers
received a virtual tour through detailed descriptions
of everything from architectural details to the floral

171 "Stirring Rally for Suffrage in Fayette," *Pittsburgh Post-
Gazette,* July 30, 1915, 7.

arrangements. Graciously and strategically, reporters included the names of all of the people involved; among the familiar ones was the wife of M.M. Cochran.

Perhaps the most interesting newspaper image from the event is a photograph of Sarah Cochran that ran in the *Pittsburgh Daily Post* the day afterward. The suffrage movement often used photos of its supporters to show that they were not the ugly caricatures that certain anti-suffragists depicted. In this case, Sarah is shown in profile from the shoulders up, with her hair back and wearing what look like a pearl choker and earrings. Her portrait neckline fades gracefully as if into clouds, and the entire image is encircled by an elegant frame that could belong in a museum. In that one image, the farmer's daughter, trustee, business owner, activist, benefactor, builder, wife, and mother—the female citizen—is a picture of femininity with the dignity of a respected older man.

Methodist Influencer

Although Pennsylvania's suffrage referendum was ultimately defeated, Sarah did not stop using her home for causes she supported. Later that year, she began plans for another headliner event at Linden Hall. This time she would host the Methodist bishops' meeting at her home. There are two stories about how this came about. One is that Dr. Thomas

N. Boyle attended Linden Hall's dedication and suggested that Sarah invite the bishops to meet there. Another story is that the Methodist Episcopal Bishop Hamilton of Boston was in Dawson to preach at the Cochran Memorial Church in the spring of 1915. At that time, he visited Linden Hall and was impressed. In either case, during the Methodist Episcopal bishops' semi-annual meeting in Washington, D.C. that November, Dawson's pastor, Rev. Baum, personally delivered an invitation from Sarah Cochran to hold the bishops' next meeting at Linden Hall. The bishops accepted.

The invitation grabbed headlines because this meeting had reportedly never been hosted at a private residence. When the bishops convened in Des Moines, Iowa, the previous spring, they were assigned host families while they held ten days of meetings at a church facility. Linden Hall would be a fantastic opportunity for the bishops to hold executive sessions and stay in one place. That the mansion was beautiful and part of a bucolic setting was certainly an added bonus.

Perhaps individual Methodists wondered why the meeting would need to be at a private home, and it's possible that some wondered whether this coal and coke operator had an agenda. Sarah was already a trustee of Methodist-affiliated colleges. On American's board, she was serving over a period

of years with five of the bishops who would attend the meeting; in addition, she and Bishop Thoburn of Meadville would have at least known of each other through Cochran Hall's dedication ceremony at Allegheny College. She had also built several Methodist churches by the time she extended her invitation, so hosting the meeting would probably not have been a springboard to bigger opportunities within the Methodist community. It's possible that she was pleased to show them the home of a well-traveled, philanthropic, politically active, successful woman. Perhaps she viewed it as a way to support her religious community in some way. As Connellsville's *Daily Courier* reported, Sarah provided everything for the meeting;[172] while no financial value was mentioned, this would not have been a small venture.

The meeting could have also been an opportunity for western Pennsylvania to capture the bishops' attention for a future quadrennial meeting. Back at the bishops' Des Moines meeting in 1915, politicians attended and gave speeches asking the bishops to consider the city for a future quadrennial. The quadrennial meeting, as the name suggests, was held every four years. It could attract thousands of delegates from all over the world because it was where the most important decisions on church doctrine were made. Much like a large convention,

172 "Bishops Meeting at Cochran Home Comes to a Close," *Daily Courier* (Connellsville, PA), April 27, 1916, 1.

each quadrennial could have a different host city that would benefit from visitors spending money on food, lodging, activities, and souvenirs. For example, the May 1916 quadrennial was already planned for Saratoga Springs, New York. Railroads advertised discounted rail tickets, and newspapers reported that local shops were stocking their wares for visitors while hotels and spas expected to do good business between the visiting Methodists and the spa town's usual visitors.

A Holy House Party

Ultimately, more than twenty bishops met at Linden Hall from April 16th to 26th. "Abraham's entertainment of the three angels from heaven is the only house party on record that in any way eclipses, in holy orders, the party of 30 bishops coming from all parts of the world," gushed Marion Damhman of the *Pittsburgh Daily Post*.[173] The timing coincided with Easter and Holy Week, but it allowed the bishops to travel to the quadrennial meeting in Saratoga Springs afterward. This enabled bishops who were arriving from China, Africa, Switzerland, and South America to participate in both meetings. At the bishops' meeting, all of the executive meetings were at Linden Hall. There was no need for the

173 Marion H. Damhman, "House Party of Thirty Bishops," *The Pittsburgh Daily Post*, April 23, 1916, 16.

bishops to leave the premises except to participate in religious services at the Cochran Church in Dawson and deliver Easter services throughout western Pennsylvania's churches.

Newspapers reported that the bishops' main objective was to develop the episcopal address communicating the Church's official position on important matters. That address would be given at the quadrennial meeting in Saratoga Springs the next month. Another objective was reportedly a discussion of how the Northern and Southern Methodists might reunite since their separation over slavery before the Civil War. A third topic that made headlines was the possible removal of a rule on amusements in the *Book of Discipline* that forbade card-playing, theater attendance, and dancing, but was apparently subject to interpretation.

The bishops had several opportunities to experience western Pennsylvania's commercial and Methodist communities during their ten days at the mansion. On Easter, each bishop preached at a different church in the region. On one of the meeting days, Henry J. Heinz reportedly traveled from Pittsburgh to have lunch with the bishops, although his diary didn't indicate the event at all.[174] While newspapers gave no reason why he participated, he would have been an interesting dining companion for religious

174 "Bishops Do Not Expect to Lift Ban on Pleasure," *Daily Courier* (Connellsville, PA), April 21, 1916, 1.

and business reasons. In the past, he had been associated with the Methodist Church and more recently was a leader in Sunday school development through the Pennsylvania State Sabbath School Association (PSSSA) and related international organizations. He held leadership positions in international Sunday school organizations and was PSSSA's president in 1907,[175] the year when Sarah was a patron of the Universal Sunday School Exposition in Rome. As an influential and wealthy businessman, he was involved in Pittsburgh's Civic Club, Chamber of Commerce, and Civic Commission, and had become well known as a paternal capitalist like the Cochrans. Perhaps he and Sarah might have already known each other through religious, professional, or Pittsburgh circles, or perhaps someone else made the connection.

To end the event, Sarah brought the community to the bishops when she hosted a five-hundred-person reception in the bishops' honor. According to Connellsville's *Daily Courier*, these guests included clergy and prominent men and women from the region. They arrived in cars and even by a special Pennsylvania & Lake Erie train[176] to find floral decorations from Linden Hall's greenhouses and a beautifully decorated conservatory. Sarah reportedly stood in a receiving line with the bishops. Perhaps this was

175 Skrabec, *H.J. Heinz: A Biography*, 189.

176 "Mrs. Cochran Is Hostess to 500 at Linden Hall Home," *Daily Courier* (Connellsville, PA), April 26, 1916, 1.

simply because she was the event host, but it was a contrast to the reception at the bishops' Des Moines meeting the previous year. At that reception for 2,500 people, newspapers reported a receiving line of only bishops, and women served food. Sarah's presence in a receiving line of male bishops would have been a powerful optic at a time when women's suffrage was a public discussion. It might have visually suggested where women were going in the Methodist Church; women had been allowed to be lay delegates at the quadrennial meeting only since 1900. For Sarah in particular, it was also a powerful promotion since a certain 1904 smoker for coal and railroad industry men. At that event, her role was to assist the daughters of Washington Coal & Coke's general manager with entertaining men, some of whom worked for the companies she founded and owned.

The Stormy Petrel

Most everyone must have known of Sarah's suffrage rally the previous summer; some might have still remembered Anna Howard Shaw's words. It would seem that her views on women's enfranchisement would have been clear by this point. However, Bishop Neely of Philadelphia didn't share her viewpoint, and his Easter Sunday preaching stood out among that of the bishops in newspapers. On Easter Sunday, the very accomplished and influential bishop

was reported as speaking to the Men's Christian Workers' League about how the church's preaching lacked virility, explaining that there weren't more men in the church because of "a natural depravity in men which keeps them away from the church; others are depraved by habit."[177] During the same address, the local newspaper quoted him as he ventured into a subject near and dear to his hostess. "If women exerted the right influence men would not need to use the bullet nor women the ballot," he said. According to that quotation, voting either had nothing to do with full citizenship rights, or a woman's role was to influence rather than directly create change. It begs the question of what men were doing with full political power if women weren't in positions to influence them. One can only imagine how Anna Howard Shaw might have responded.

When Bishop Neely died in 1925, *The Philadelphia Inquirer* ran an obituary that covered the eighty-five-year-old's colorful opinions, which spanned Delaware River bridge traffic noise, the increased number of Philadelphia drug stores, and significant church issues. He was remembered as being opposed to both women's full admission to the ministry and the union of the Northern and Southern Methodist churches. Apparently, the General Conference had brought about his retirement as a result of his

177 "Bishop Neely Says Feminism in Religion Keeps Men Out," *Daily Courier* (Connellsville, PA), April 24, 1916, 1.

reputation as the "Stormy Petrel." One is only left to wonder how the Stormy Petrel and the Coal Queen got along during the ten days at Linden Hall.

Sacred Space

In the end, local newspapers reported that the bishops were "charmed" by the place and its owner before venturing to Saratoga Springs for their quadrennial meeting that would begin on May 1st. Just like that, the "angels" had vanished, and Sarah had her home back to herself again. Ironically, her home—typically the place considered the most private and traditionally most associated with a woman's place—had just been a vehicle for public support of her political and religious beliefs.

Epilogue: The Ministry of Woman

O ne day in the 1920s, there was terrible wind during a storm in the Dawson area. At Linden Hall, Sarah held a door open for servants who were moving furniture inside, but a strong gust forced her against a piece of furniture. Her action was interpreted as an act of her "democratic disposition,"[178] but she fractured both her thigh and one arm in the process.[179] Afterward, she was a semi-invalid for about fifteen years, and her brother Herbert Moore and his wife lived at Linden Hall with her during

family

178 "Mrs. Sarah B. Cochran's Death Closes Long Life Devoted to Human Needs," *Daily Courier* (Connellsville, PA), October 28, 1936, 1.

179 "Sarah Cochran Dies at Family Home in Dawson," *Morning Herald* (Uniontown, PA), October 28, 1936, 5.

some of that time. Sarah was able to escape the western Pennsylvania winter of 1921 to 1922 by renting a house for the season in Augusta, Georgia. But by about 1933, she wasn't even able to attend church regularly in Dawson. When the West Virginia Alpha Chapter of Phi Kappa Psi sent her their annual Mother's Day flowers in 1935, she wrote a lengthy address with her thank-you note (see Appendix). In it she reflected on her own parents, uncles, and childhood, and shared her advice about motherhood. She said that she wasn't getting out very much and shared the musical advice she had heard a few days earlier on Dr. Walter Damrosch's radio show. It's possible that she was hearing his "Music Appreciation Hour" series, which he produced for radio at that time.

Until the end, Sarah seemed to try to engage with the larger world and continue to learn. She died on October 27, 1936, of general arterial sclerosis after a few months of serious decline in health. The funeral was held at home, and then she was buried with her family at Cochran Cemetery. She was said to have been buried wearing pink and lavender, which were the old colors of Phi Kappa Psi. Banks where she had been a director in Dawson and Perryopolis were closed for the funeral. At the October meeting of the Women's Foreign Missionary Society of the Methodist Episcopal Church, Sarah was remembered in a special talk.

The Ministry of Woman

On November 8, 1936, someone laid flowers at both ends of Sarah's pew in the Methodist church's sanctuary in Dawson. Her memorial service was going to take place that day. At Sarah's request, the memorial service was to be for the community at large. Elements of it were like any memorial that came before or after it: The congregation and choir sang her favorite hymns, and representatives of the church board, its Sunday school, and congregation made addresses. However, the church's minister, Rev. Dr. Thomas Charlesworth, delivered a sermon called "The Ministry of Woman," publicized as dealing "with the influence of woman, from the Biblical viewpoint, and ... illuminated with incidents from the lives of great Bible women."[180] Then church leaders spoke of Sarah's life and influence in the community.

Unfortunately, a written copy of the service doesn't seem to have survived, so it is unknown which Biblical figures were included, how their merits were interpreted, or exactly what message was left with the mourners. But just as Philip Cochran's will was fascinating because it made concrete his complete trust in Sarah, the service's theme was telling. Sarah or the minister could have chosen a number of

180 "Memorial Service at Dawson Church for Mrs. Cochran,"
 Daily Courier (Connellsville, PA), November 6, 1936, 6.

themes that might have had meaning from the many aspects of her life: Methodist faith, the rich and poor, ethics, humility, community service, or education. Instead, her life publicly closed with thoughts about the influence of women.

Later that month, Rev. Dr. Charlesworth and the church board passed a resolution on her life, calling her a "noble Christian woman, regular in attendance on the means of grace at the church as long as health permitted; an active worker, taking her share of the responsibilities of the church" and as one whose "beautiful life, smile, words of cheer and deeds of kindness were always encouraging to the members and friends of the church."[181] *The 1937 Journal of the Pittsburgh Conference of the United Methodist Church* recorded the unanimous adoption of a resolution on Sarah's life that Rev. Dr. Charlesworth presented. It recognized her "beautiful and useful life" and thanked her for the bequests in her will to Allegheny College, the church in Dawson, and the missionary cause.[182] At the end, Sarah's life echoed Henry Drummond's words that she had admired so much. As Drummond wrote, "You will find as you look back upon your life that the moments that stand

181 "Dawson Methodists Adopt Resolutions on Life and Death of Mrs. S. B. Cochran," *Daily Courier* (Connellsville, PA), November 25, 1936, 3.

182 Western Pennsylvania Annual Conference of the United Methodist Church, *Official Journal and Yearbook*, 154.

out, the moments when you have really lived, are the moments when you have done things in the spirit of love."[183]

A Paper Trail

Among the paperwork that closed out her life and estate was her death certificate, which recognized her career by indicating that she was simply "retired." Her will was able to capture her interests because it enumerated all of the money that would be transferred to colleges, fraternities, the Methodist Church, and individuals. Linden Hall was willed to her brother, Herbert Moore, and his wife.

On a more intimate level, the will's letter of instruction disbursed roughly twenty pieces of jewelry to specific people. Even if she didn't believe that meaning derived from things, it was still clear that some things had special meaning. Her platinum emerald wedding band, a diamond pin with a portrait of Philip, and a pin and ring from Phi Kappa Psi were among the pieces named. The letter didn't suggest whether this was all the jewelry Sarah owned or just what she had at the end. Jewelry could be interesting in her case because it often visually communicates wealth, lifestyle, and even social rank, and Sarah's adult life spanned rather bejeweled eras with distinct design styles, like Victorian, Edwardian, Art

183 Drummond, 60.

Nouveau, and Art Deco. Rings and brooches made up the bulk of the list, and while there were some pearls, most of her pieces featured precious stones—many diamonds, a number of sapphires, and just single references to a ruby or emerald. She described each piece in basic detail, such as the "little pin...known as the Tiffany pin (diamonds and two pearls)"[184] to distinguish one piece from another. Because she omitted size, style, designer, and value, it's difficult to determine the jewelry's physical appearance or Sarah's personal style.

Multiple obituaries ran in newspapers, some more detailed than others. As a group they provide a snapshot of how Sarah's life was viewed in 1936, and in some cases, they indicate how Philip was remembered, either because he was considered the source of Sarah's wealth or because he was still respected. *The Pittsburgh Press* ran just three robust sentences to publicize her funeral services. Within those, it credited Sarah with "a career of philanthropies" and placed a dollar value on that career: her public philanthropy was worth $2 million; and her private philanthropy, hundreds of thousands of dollars. It placed business within Philip's purview, explaining that his "position in the coke industry years ago paralleled that of

184 Sarah B. Cochran, will dated November 18, 1933, proved
 November 2, 1936, Fayette County Register of Wills,
 Uniontown, PA.

H.C. Frick."[185] Connellsville's *Daily Courier* wrote one of those obituaries that becomes a gold mine for genealogists, full of personal and professional details. While it reviewed Philip's accomplishments and Sarah's philanthropic work, it also described Sarah's business pursuits: "Mrs. Cochran was one of the founders and stockholders of the Cochran Coal & Coke Company of Morgantown, W. Va., and the First National Bank of Perryopolis." In Meadville, Allegheny College's *Campus* remembered her as one of the college's "chief benefactors."[186] Various newspapers covered her estate's settlement, which one writer expected to be worth over $4 million at the time.[187]

What Sarah Left Behind

No one's legacy lies solely in paperwork. If we are what we leave behind, it's worth considering what Sarah left behind. There are the large, publicly impressive things, like buildings. A new Phi Kappa Psi house in Morgantown was named for her. Cochran Hall still stands at Allegheny College, but Cochran Hall at Otterbein University burned in the 1970s. Sarah's church is still in use in Dawson and on

185 "Taken by Death," *Pittsburgh Press*, November 1, 1936, 7.

186 "Sarah B. Cochran, Friend of Allegheny, Passes Quietly Away," *Campus*, November 4, 1936.

187 "$4 Million Will Mailed South," *Pittsburgh Press*, November 6, 1936, 53.

the National Register of Historic Places. Linden Hall is also on the National Register but has been through a series of owners since Herbert Moore's death. Even Agnes Northrop's spectacular Tiffany window was sold for $6.8 million in 2005.[188] Beyond the architecture, all of these structures are important parts of the built environment because their existence proves that a woman could build these, that she used her power and unapologetically took up space in the world.

Sarah left behind a more educated community in the form of townspeople who were able to attend college and have careers and life experiences that wouldn't have necessarily been available to them without her help. Education could be a benefit for these people, and even for their families generations later. Her education of teachers elevated the quality of schools in rural Fayette County. However, schools can change over time, and many people have left southwestern Pennsylvania to find work elsewhere since Sarah's lifetime. Perhaps some would argue that some of that legacy relocated, too.

As the first female trustee of Allegheny College, Sarah pioneered a place for women in this college's particular leadership position. There are some who would say that people aren't aware of who has served on a board of trustees or who is even serving

188 Richard Robbins, "Old Coal Kings," *TribLive*, January 2, 2005, http://triblive.com/x/pittsburghtrib/news/regional/s_288197.html.

currently. There is even institutional memory loss over time. The endowed chair named for Clarissa Cochran did not even last past Sarah's lifetime. For that matter, the fact that the 1916 Methodist bishops' meeting happened at Linden Hall doesn't seem to be common knowledge over a hundred years later. Like many events and artifacts from the American women's suffrage movement, the 1915 suffrage rally at Linden Hall also seemed to have been forgotten for years, like the suffrage paraphernalia that seemed irrelevant after the 19th Amendment was added to the Constitution.

If many of her contributions to the world can be forgotten or lost, then exactly what did Sarah leave behind for those of us living in the twenty-first century? Why should we still know of her after all of these things are gone? Perhaps her story is what was left behind for us. It has a universality to it that could make her legacy more powerful and far-reaching. It can travel around the world, survive over time, and inspire people who may never have a reason to venture to any of the places that were part of Sarah's life.

Just as Henry Drummond argued that love is eternal and kindness is an act of love, I would argue that telling a person's story is an act of love, both for that person's memory and for the listener whose potential might be activated by knowing it. Just as a doctor made Sarah aware of her power to help people,

stories have the potential to activate individuals' latent power. They reflect our values and choices and teach us what to take for granted. If we're aware of powerful but obscure stories and places, perhaps we have an obligation to enlarge the audience who knows about them. Otherwise, our potential could be restricted to the limited visions of less-informed people, regardless of what our reality has been. We will be the same as census takers who assumed that women didn't have occupations and left records with data that was sometimes out of step with reality.

I think of Sarah as one of the lesser mortals, so to speak, in a place and time that would often be associated with the philanthropy and business activities of Henry Clay Frick and Andrew Carnegie. There are two reasons why her story is so important, and both assume that there are other Sarah Cochrans out there. First, her obscure story, and the act of giving it a broader audience, might inspire other people to do the same with other lesser mortals. Just as Sarah's impact wasn't well-recorded in certain documents that could have affected public policy, perception, and the historical narrative, other individuals have surely remained off the radar. There is much to be gained if stories and data are made visible to academic and general audiences. Just as Sarah claimed space for herself and her causes in public, we must claim space for these people in the collective memory and

historical narrative. Often this space is manifested in the written word, such as books, or through the built environment, as in historic sites and landmarks. However, archives and museums offer another very powerful, and sometimes overlooked, space to claim. Donating original artifacts—or images of them— from attics and basements to archives and museums ensures their proper care and preservation. It also ensures accessibility to people across the planet who can use the information in academic and genealogical research. In this case, genealogists and family historians have the potential to offer a wealth of information from their research on lives that might otherwise remain obscure to many.

Second, each of us—like Sarah—has some power that we can use when we choose to engage with the world. Her life is an example of how to use our power where we are instead of retreating from difficult situations. It's true that we may not be the coal queen or woman of large affairs that she was, but it's also true that she didn't have the same wealth or philanthropic reach as Andrew Carnegie. For many years, she didn't even have the same rights as the men who served on boards with her or the men she employed. Her wealth couldn't keep her husband or son alive, and her humble beginnings might have remained an impediment in some circles. Regardless of how powerless and alienated this could have made her feel,

she found her power, engaged with the world, and advanced the people, causes, and communities that mattered to her. Not only did she effect change, but in doing good for others she might have improved her own life.

* * *

This story that began with one baptism ends with another. A few years ago, my husband and I packed our five-month-old daughter into our car and drove from New Jersey to Dawson to baptize her in Sarah's church, where I had been baptized. My father, my husband's parents, a godmother, and my great-aunt and great-uncle gathered quietly in the sanctuary, just outside the *Sistine Madonna's* gaze. The pastor led us through the ritual with the words that many before us had spoken. My daughter's spiritual journey began in the same place where mine had begun, where my parents had married and my grandparents had been trustees, and next door to the parsonage where two great-grandparents had married nearly a hundred years earlier. It was both a full circle and a linear progression, and I was grateful to have a place and a story that I could share with my child. I don't know how often she will visit western Pennsylvania given that her family is centered in New Jersey, and I'm sure she won't remember her first trip there any more than I remember mine. But I already tell her stories.

On the six-hour car trip back to New Jersey, my husband and I talked about how I could tell Sarah's story given my skills and my perspective as a distant relative. Without realizing it at the time, I was beginning the journey of writing this book. It was a journey that fused skills and knowledge from business, academic training, volunteerism, and genealogy that wouldn't have otherwise come together. I met new people and challenges and learned a great deal. At times I was surprised or gratified. Like a literal journey, this one included photographs, but in this case I sent digital copies of historic photos to archives, and original artifacts with historical data—but little personal meaning—went to archives for wider accessibility.

Most importantly, this journey connected a community of people who cared about Sarah Cochran and put this important story in the world. I hope it will inspire others to take similar journeys.

Appendix

The following is Sarah B. Cochran's letter to Phi Kappa Psi's West Virginia Alpha Chapter dated May 24, 1935, as it was transcribed in the book In the Bond: 100 Years within West Virginia Alpha. *She wrote it in the third person, referring to herself as the mother in question. It was intended to be read in her absence, given that she had become an invalid and unable to travel. It was part of a thank-you note for Mother's Day roses that the fraternity chapter had sent her. It is reprinted in its entirety with permission of the book's author, David L. Woodrum. The book's full citation is included in the bibliography.*

"I was talking with a mother the other day, and she reverted, with great joy and appreciation to her childhood home—her parents, her mother. She was realizing more and more as the years passed what a part they had played in her own character-building and in her own home and the privilege of motherhood

which later came to her. I think I should like to tell you some of the things she said.

"She began: 'I want to tell you what a dear sweet mother I had. I can still, after many years, feel the touch of her soft white hands, in illness. She had great influence of her brothers. I remember reading a letter one of them, who was in the Civil War, wrote to her. He said, 'Sarah, don't worry about me. In my tent we are holding a service of prayer while in the next tent they are playing cards. If I fail here, it is only to rise higher.'

"Before she died, (this mother continued) her last words were, Lord be merciful to my children. I remember too my saintly father and wonderful prayers he used to offer—real prayers, from his heart, not merely empty words. When he died I felt I could never listen to anyone else pray.

"So the kindly, loving influence, the Christian atmosphere, the earnest prayers of these parents lived on in the heart and life of this mother I am telling you of. This mother had just one son, and her constant prayer was that he be kept from sin. But besides praying, she saw to it that the atmosphere of the home was free from any gossip or scandal, that truth and love prevailed. She said to me, 'Oh, I wish I would tell all the mothers, especially the young ones, to keep their children close to them—never to let them hear unkind words spoken or any slander in

their homes. Rewards will come. My own son never deceived me. He never told me an untruth. It was a reward to hear the principal of his preparatory school say, 'We should live to have your son return for his example to the other boys.'

"Illness came upon this son, it proved to be his last; but the mother had this comfort, even in that hour, to hear him say when the doctor prescribed some liquor: 'This, Mother, is my very first taste.' He passed on, and overwhelming grief gripped this mother. For a long time she was prostrated and her tears fell unceasingly.

"One day a young doctor came to see her. He told her not to lie and weep. There was so much good she could do, schools and churches she could aid. So, by this timely word, the gall of her affliction was transformed into the balm that comes from thinking and working for others. She said, 'I found new light in the world, new trust in God in my hope of doing good.'

"This mother made some very practical suggestions for holding children in the home; kindness, fairness and above all, love. 'Every mother should have a copy of Henry Drummond's book—*The Greatest Thing in the World*—and live it. Then a mother must show an interest in the activities of her child, in his schoolwork, his playmates, the mother should provide the right sort of reading matter and have the children sing, at home and in the church.

Madam Schumann-Heink when in Uniontown a few years ago, strongly advised her audience to encourage the children's singing. Just a few days ago, Dr. Damrosch, speaking over the radio, supplemented this advice by saying that music in the home was one of the strongest family ties. Let the children learn to play some instrument; have your own home orchestra. Home will be an attractive, inspiring place—a place which these children will look back to and which will serve as a pattern for them, when they have added years and in turn are the fathers and mothers of this community.'"

Acknowledgments

There are many people and organizations that deserve thanks and acknowledgment for helping me bring this book to fruition. In the spirit of a coal baron, I would name a blast furnace or a mining complex for each of you if I could.

Let me begin with those associated with organizations in western Pennsylvania. Thank you to Amanda Peters, archivist of the Coal and Coke Heritage Center at Pennsylvania State University, for helping me find resources about the culture and industry of coal and coke. I appreciate the help of my great-uncle, Roy Hess, Sr., who chairs the board of trustees at the Philip G. Cochran Memorial United Methodist Church and is a former recording secretary of the Tri-Town Area Historical Society. The Fayette County Historical Society has been an invaluable source of contacts, and I am grateful to its president, Chris Buckelew, and to Tom Buckelew

and Dorothy Gruskowski for providing information and encouragement before this book project began. I am especially thankful for the insights and encouragement of Donna Edwards-Jordan, whom I met through the Society. Jackie Campbell and John R. Wilson of the Western Pennsylvania Conference of the United Methodist Church were extremely helpful in directing me to church photographs and histories of Methodism in western Pennsylvania. Thank you to Samuel J. Richards for providing information about Trinity Hall School, encouraging my research on Methodism, and providing developmental feedback for the book's structure. During research for my previous writing about Sarah, Eugene Lint, curator emeritus of Linden Hall, was very generous with his time and knowledge, and that information positioned me well to research Sarah's story in more depth for this book. I also thank Bill Meloy of California University of Pennsylvania's Manderino Library and Harrison Wick of Indiana University of Pennsylvania for their helpful research insights and encouragement. encouragement" to read "Many thanks to Uniontown Public Library's Pennsylvania Room staff.

This book would not be possible without the time of many archivists. In addition to those named above, several helped me consider Sarah within the larger context of women's history: Kathleen Banks

Nutter and Karen Kukil of the Smith College Special Collections were enormously helpful in directing me to resources about women's labor and female college trustees. It was exciting and quite helpful to find Dr. Anna Howard Shaw's 1915 diary at the Arthur and Elizabeth Schlesinger Library on the History of Women in America at the Radcliffe Institute for Advanced Study. Thank you to Jennifer Fauxsmith for her help with that. Suzanne Gould, as archivist and historian of the American Association of University Women, provided me with historic documentation about female college trustees and women's college housing, for which I am grateful. In addition, the archives of the colleges where Sarah was a trustee or donor were fantastic resources that enriched my understanding of Sarah's philanthropy. I thank Sheree Byers and Ruth Andel of Allegheny College's Merrick Archives, Adam Hess of Arcadia University, and Leslie Nellis of the American University Library. Stephen Grinch of Otterbein University's Courtwright Memorial Library, Sharon Monigold of Bethany College, and Christelle Venham and Jessica Eichlin of West Virginia University were also extremely knowledgeable and helpful. At Stanford University, I want to thank Jessica Ventura of the Cantor Arts Center and Leif Anderson of Special Collections for helping me research in Stanford's collections. Many thanks to Joseph-James Ahern at the

University of Pennsylvania's Archives. I am also grateful to have been able to access the information in the collections of the University of Pittsburgh, the Detre Library & Archives at the Senator John Heinz History Center, and the Frick Library in New York City.

Many thanks to Andrea Pactor, in her capacity as the interim director of the Women's Philanthropy Institute at Indiana University Lilly Family School of Philanthropy, for her enormous encouragement and valuable resources about American women's philanthropy in history. I am grateful to Joan M. Johnson, Director for Faculty at Northwestern University, for discussing her insights into women's philanthropy during the Gilded Age and to Margaret Mulrooney, Associate Vice Provost for University Programs at James Madison University, for answering my questions about western Pennsylvania's culture at the turn of the century.

Learning that a fraternity house was named for Sarah was a big surprise during my research. As a result of that discovery, I am happy to have been in touch with Zach Mendelson, John Miesner, Gary Waters, and David Woodrum of the James Cochran House Association and Ben Lauro of the Sarah B. Cochran House in Morgantown, West Virginia. I appreciate all of the historical information and insights they shared about Sarah's involvement with Phi Kappa Psi's West Virginia Alpha Chapter. The

Chapter's transcription of a personal letter from Sarah Cochran was a treasure for understanding more about how she was able to thrive after tragedy.

Special thanks to Fayn LeVeille of the Halifax Historical Society Museum, Becky Dozier of the Augusta Genealogical Society, and Serena McCracken of the Atlanta History Center for tracking down information in Florida and Georgia. I also appreciate the assistance of Lee Arnold at the Historical Society of Pennsylvania and Buff Barr at the Hunterdon County Library.

It is a wonderful coincidence that this book incorporates some of the genealogical research that I conducted for personal use many years ago. I am thankful to have had access to the resources at the David Library of the American Revolution (now The David Center for the American Revolution at the American Philosophical Society) and the Monmouth County Historical Association Research Library and Archives in Freehold, New Jersey.

Going from a manuscript draft to a book was a project. There aren't enough words of thanks for my editor, Christian Kirkpatrick, and her editorial services and expertise. Her work on my manuscript made it better, and it was a pleasure to work with her. I'm also grateful to have a wonderful team at Books Fluent and Books Forward to handle publishing and publicity so that Sarah's story can reach a larger audience.

Many people were encouraging throughout this process, and I sincerely thank those who have followed its progress for the last two years. I'm especially grateful to my late friend, Paula Davidson, for encouraging me to take this journey when it was still just a thought. Thanks to Katie Burke, Gloria Forouzan, Donna Griffin, Marylu Korkuch, Keya Koul, Lynne Noel, Sarah "Swilson" Rimkunas, Abby Slater, Dara Weinerman Steinberg, and Tori Wright for providing feedback during the process. My mother- and father-in-law, Julie Toigo and Serge Toigo, have been extremely supportive in this process, and I'm thankful for their encouragement of my writing. Thank you to my aunt and uncle, Murray and Joyce Boyd, and my stepmother, Joan Schwarzwalder, for their ongoing encouragement and interest in this project.

My parents' commitment to visiting western Pennsylvania so often as I grew up gave me the gift of being connected to two different parts of the country and to my family history. It also introduced road trips with eight-track tapes and travel skills that encouraged me to see the world and think broadly about what I considered "local." I'm grateful for all of those things and will always remember trips across the Pennsylvania Turnpike with my parents and schnauzer, once with a Christmas tree strapped to our van's roof. Thanks to my father, Harry Hess, for reading and providing feedback on an early

manuscript draft and for encouraging my work. My mother, Carole Hess, passed away before I began this book, but she has a presence in it because she was the first person who taught me that women's voices, experiences, and labor have value.

Most importantly, I thank my husband, Mark Toigo. He encouraged and believed in this project before I ever seriously considered it, always offered encouragement, and helped me to make it happen.

Bibliography

Allegheny College. "History — Cochran Hall." https://sites.allegheny.edu/alumni/history-co-chran-hall/.

Alpha Phi Quarterly. "General College Notes," 21, no. 2, (February 1909): 113. Google Books.

American University. "Board Membership 1891-Present." https://www.american.edu/trust-ees/historic-list.cfm.

American University Courier. "Coal by the Carload." January 1921. https://archive.org/details/univer-sitycourie9226amer/

———. "Old King Coal." January 1922, https://archive.org/details/universitycourie9226amer/.

———. "Some of Our New Trustees." March 1916. https://archive.org/details/universitycou-rie9226amer/.

Augusta Chronicle (GA). "Personal Mentions." January 25, 1921. GenealogyBank.

American University Bulletin, "Board of Trustees,"
July 1929, 4, no. 7, 5-7. archive.org/details/ameri-
canuniversity.

Barnes, Walter. "West Virginia Alpha — University
of West Virginia." *Shield,* 24, March 1904, 457.
Phi Kappa Psi Archive.

Bernard, Frances F. "The Tenure of Office of
Trustees." *Journal of the American Association of
University Women* 15, no. 3 (April 1922): 63-69.

Bradley Hagerty, Barbara. *Life Reimagined: The
Science, Art and Opportunity of Midlife.* New
York: Riverhead Books, 2016.

Brestensky, Dennis F., Evelyn A. Hovanec, and
Albert N. Skomra. *Patch/Work Voices: The
Culture and Lore of a Mining People.* Pittsburgh:
University Center for International Studies,
University of Pittsburgh, 1978.

Brooklyn Daily Eagle. "A Handsome Window."
October 3, 1912, Newspapers.com.

Caduceus of Kappa Sigma. "Chapter Letters as Once
They Were Writ." , 23, no. 1, (1908): 381. Google
Books.

Caduceus of Kappa Sigma. "The Greek Press." June
1905, 588. Google Books.

Cameron, Samuel M., Mark P. Curchack and
Michael L. Berger. *From Female Seminary to
Comprehensive University: A 150-Year History of
Beaver College and Arcadia University.* Glenside,

PA: Arcadia University, 2003.

Campus of Allegheny College. "Campus Being Planted with Many Fine Shrubs." November 3, 1914. Allegheny College DSpace Repository.

———. "Cochran Commons Formally Presented." April 18, 1908. Allegheny College DSpace Repository.

———. "Concerning Mrs. Sarah B. Cochran." May 25, 1912. Allegheny College DSpace Repository.

———. "Dr. Crawford Delivers Last Baccalaureate." June 16, 1920. Allegheny College DSpace Repository.

———. "Half Million Endowment Fund Completed on Last Wednesday; Endowment Now Over a Million." April 27, 1912. Allegheny College DSpace Repository.

———. "New Church Is Given by Sarah B. Cochran." December 8, 1927. Allegheny College DSpace Repository.

———. "President Talks." April 27, 1912. Allegheny College DSpace Repository.

———. "Sarah B. Cochran, Friend of Allegheny, Passes Quietly Away." November 4, 1936. Allegheny College DSpace Repository.

———. "The Catalogue Remodeled." March 13, 1909. Allegheny College DSpace Repository.

———. "The Liberal Lady Elect." September 30, 1911. Allegheny College DSpace Repository.

———. "Women's Gymnasium Formally Presented." December 5, 1905. Allegheny College DSpace Repository.

Civic League of Milton, PA, "Penna. Laws for Women." *Lewisburg Chronicle* (PA). December 6, 1902. Newspapers.com.

Cloonan, Pat. "Small Town Life: Star Junction — Inconspicuous Town Once the Site of 999 Coke Ovens." *Herald Standard.* July 23, 2017. https://www.heraldstandard.com/new_today/small-town-life-star-junction-inconspicuous-town-once-the-site-of-999-coke-ovens/article_793f7fbc-350e-5e36-adba-5c217cbd4989.html.

Cotton States and International Exposition. *Official Book of the Pennsylvania Building and Catalogue of Keystone State Exhibitors.* Collection of the Kenan Research Center, Atlanta History Center.

Council of Independent Colleges. "Cochran Hall." Historic Campus Architecture Project. Accessed September 28, 2017. Artstor.org.

Crocker, Ruth. *Mrs. Russell Sage: Women's Activism and Philanthropy in Gilded Age and Progressive Era America.* Indianapolis: Indiana University Press, 2006.

Daily Courier (Connellsville, PA). "Bishop Neely Says Feminism in Religion Keeps Men Out." April 24, 1916. Newspapers.com.

———. "Bishops Do Not Expect to Lift Ban on Pleasure." April 21, 1916. Newspapers.com.

———. "Bishops Meeting at Cochran Home Comes to a Close." April 27, 1916. Newspapers.com.

———. "Bishops Resume Conferences at St. James Park." April 24, 1916. Newspapers.com.

———. "Clarissa Mine Closes Down." August 21, 1912. Newspapers.com.

———. "Cornerstone of M.E. Church Will Be Laid Sunday." April 30, 1927. Newspapers.com.

———. "Dawson Methodists Adopt Resolutions on Life and Death of Mrs. S. B. Cochran." November 25, 1936. Newspapers.com.

———. "Florence Mine Property Sold to Jesse Welling." October 1, 1928. Newspapers.com.

———. "He Gave a Smoker." December 8, 1904. Newspapers.com.

———. "Memorial Service at Dawson Church for Mrs. Cochran." November 6, 1936. Newspapers.com.

———. "M.M. Cochran Dies in Uniontown Home; Funeral Saturday." November 27, 1936. Newspapers.com.

———. "Mrs. Cochran Is Hostess to 500 at Linden Hall Home." April 26, 1916. Newspapers.com.

———. "Mrs. Lucien Smith on List of Saved." April 16, 1912. Newspapers.com.

———. "Mrs. Sarah B. Cochran's Death Closes

Long Life Devoted to Human Needs." October 28, 1936. Newspapers.com.

———. "News of Tri-Town Community." October 29, 1936. Newspapers.com.

———. "Open House Marks Golden Anniversary." December 20, 1971. Newspapers.com.

———. "Out of the Past." August 21, 1975. Newspapers.com.

———. "Will Invite Bishop." March 8, 1915. Newspapers.com.

———. "25th Anniversary of Star Junction Church Next Week." January 10, 1923. Newspapers.com.

Daily Pennsylvanian. "College Student Dies." University of Pennsylvania Libraries Digital Collection, March 6, 1901. https://dparchives. library.upenn.edu/?a=d&d=tdp19010306-01&dliv=userclipping&cliparea=1.1%2C2910%2C2350%2C1032%2C1127&factor=4&e=------190-en-20—1--txt-txIN-james+cochran------.

Daily Telegram (Clarksburg, WV). "To Entertain Frat. Men." February 4, 1908. Newspapers.com.

Damhman, Marion H. "House Party of Thirty Bishops." *Pittsburgh Daily Post.* April 23, 1916. Newspapers.com.

Daytona Gazette-News (Daytona Beach, FL). "Palatial Home Planned." April 11, 1908. Newspapers.com.

Des Moines Register. "Bishops to Be Entertained."

April 25, 1915. Newspapers.com.

———. "Des Moines Wants 1920 Conference." April 29, 1915. Newspapers.com.

Deyarmon, T. Robb. "M.E. Bishops of the World to Meet at Linden Hall." *Morning Herald* (Uniontown, PA). November 6, 1915. Newspapers.com.

Dispatch (Pittsburgh). Untitled obituary for James Cochran. March 6, 1901. James Cochran Alumni File, University of Pennsylvania Archives.

"Donations and Bequests." *The American Educational Review,* 31, no. 1 (October 1909): 359, Google Books.

Drummond, Henry. *The Greatest Thing in the World*. New York: James Pott & Co., 1890. Google Books.

DuBois, Ellen Carol. *Suffrage: Women's Long Battle for the Vote.* New York: Simon & Schuster, 2020.

Duncan, Alastair, Martin Eidelberg, and Neil Harris. *Masterworks of Louis Comfort Tiffany.* New York: Harry N. Abrams, 1993.

Ellis, Franklin, ed. *History of Fayette County, Pennsylvania with Biographical Sketches of Many of Its Pioneers and Prominent Men.* Philadelphia: L. H. Everts & Co., 1882. Historic Pittsburgh.

"Endowment of Office and Chair of the President of Bethany College." *Bethany College Bulletin*, May

1921. https://archive.org/stream/cataloguewithc-2122beth/cataloguewithc2122beth_djvu.txt.

Enman, John A. *Another Time, Another World.* Uniontown, PA: Patch/Work Voices Publishing, 2010.

Erikson, Erik H. *Identity and the Life Cycle, A Reissue.* New York: W.W. Norton, 1980.

Evening Public Ledger (Philadelphia, PA). "Basketball Game Between Women as Curtain-Raiser for Eastern Smoke Fund." December 1, 1917. Newspapers.com.

Evening Republican (Meadville, PA). "Beautiful Window for Mrs. Sarah Cochran." October 5, 1912. Newspapers.com.

———. "The Dedication of Cochran Hall." April 24, 1908. Newspapers.com.

———. "What Fund Means to College." April 27, 1912. Newspapers.com.

Evening Standard (Uniontown, PA). "Florence Mine Comes Back to Mrs. Cochran." August 1, 1928. 14, Newspapers.com.

———. "Largest for Decade in Fayette." June 7, 1930. Newspapers.com.

———. "Linden Hall Tours Still On." October 14, 1977. Newspapers.com.

———. (Washington, DC). "Care Given Ismay as Women Suffer." April 20, 1912. Newspapers.com.

———. "M.E. Bishops to Meet." April 14, 1916. Newspapers.com.

———. "President Sends Message." June 21, 1916. Newspapers.com.

Field, Corinne T. "Age, Power and Woman Suffrage." *Schlesinger Newsletter.* Fall 2018. https://www.radcliffe.harvard.edu/news/ schlesinger-newsletter/age-power-and-woman-suffrage.

———. *Grand Old Women and Modern Girls.* (Video). https://www.radcliffe.harvard.edu/ video/grand-old-women-and-modern-girls-corinne-t-field.

Fletcher, Stevenson Whitcomb. *Pennsylvania Agriculture and Country Life.* Harrisburg, PA: Pennsylvania Historical and Museum Commission, 1950.

Forest Republican (Tionesta, PA). "Allegheny College Lucky." June 13, 1906. Pennsylvania Newspaper Archive, Pennsylvania State University.

Frelinghuysen, Alice Cooney. *The Garden as a Picture: Agnes Northrop's Stained-Glass Designs for Louis C. Tiffany.* (Video). https://america-nart.si.edu/blog-post/305/glass-gardens-agnes-northrop-designs-for-louis-c-tiffany.

Funk, W.R. "The James F. and Sarah Herbert Moore Church." *Religious Telescope.* April 30,

1902. Google Books.

Garst, Henry. *Otterbein University, 1847-1907.* Dayton, OH: United Brethren Publishing House, 1907. Otterbein University Digital Commons.

General Commission on Archives and History. "United Methodist Membership Statistics." http://gcah.org/history/united-methodist-membership-statistics.

Genius of Liberty (Uniontown, PA). "Died. Herbert." August 20, 1863. West Virginia University Libraries.

Gresham, John M., ed. *Biographical and Portrait Cyclopedia of Fayette County, Pennsylvania.* Laughlintown, PA: Southwest Pennsylvania Genealogical Services, 1986. Google Books.

Hamersly, Lewis Randolph. *Who's Who in Pennsylvania: Containing Authentic Biographies of Pennsylvanians Who Are Leaders and Representatives in Various Departments of Worthy Human Achievement.* New York: L.R. Hamersly Company, 1904. Google Books.

Henry Clay Frick business records. Carnegie Brothers & Company, Limited, 1867-1894, I, University of Pittsburgh. https://historicpittsburgh.org/islandora/object/pitt%3A31735066204367.

Herald (Rochester, NY). "Magnificent Coffin."

March 8, 1901. James Cochran Alumni File, University of Pennsylvania Archives.

Hovanec, Evelyn A. *Common Lives of Uncommon Strength: The Women of the Coal and Coke Era of Southwestern Pennsylvania, 1880-1970.* Dunbar, PA: Patch/Work Voices Publishing, 2001.

Hurll, Estele M. *The Madonna in Art.* Boston: L.C. Page and Company, 1897. https://archive.org/details/TheMadonnaInArt1898.

Jean-Laurent, Annabella. "Flashback: The 1895 Cotton States Exposition and the Negro Building," *Atlanta Magazine,* February 27, 2014. atlantamagazine.com/news-culture-articles-/flashback-the-1895-cotton-states-exposition-and-the-negro-building/.

Johnson, Euphemia. "A New Profession for College Women: The Headship of a College Hall Residence." *Journal of the Association of Collegiate Alumnae,* 14, no. 4 (January 1921): 93-97.

Johnson, Joan Marie. *Funding Feminism: Monied Women, Philanthropy, and the Women's Movement, 1870-1967.* Chapel Hill: University of North Carolina Press, 2017.

Jordan, John Woolf and James Hadden, *A Genealogical and Personal History of Fayette and Greene Counties,* vol 3. New York: Lewis Historical Pub. Co., 1912. Google Books.

Kappa Alpha Journal, 22, no. 5, (June 1905):

687-688. Google Books.

Keister family papers. Pennsylvania State University Coal and Coke Heritage Center.

Kelly, Lois. "No Mud, No Lotus." *Forbes,* January 8, 2015. https://www.forbes.com/sites/oreillymedia/2015/01/08/no-mud-no-lotus/?sh=65144cdb17a9.

Kessler-Harris, Alice. *Out to Work: A History of Wage-Earning Women in the United States.* New York: Oxford University Press, 2003.

Leonard, John William. *Who's Who in Pennsylvania: A Biographical Dictionary of Contemporaries,* 2nd ed. New York: L.R. Hammersly, 1908.

Lerner, Gerda. *The Creation of Feminist Consciousness: From the Middle Ages to Eighteen-Seventy.* New York: Oxford University Press, 1993.

———. *The Creation of Patriarchy.* New York: Oxford University Press, 1986.

Lindbergh, Anne Morrow. *Gift from the Sea.* New York: Pantheon Books, 1992.

Lint, Eugene and Patty Lint. *America's Castles: Coal Barons*, A&E, Cinetel Productions, 1996. https://www.youtube.com/watch?v=MoWguA_zK5o.

Lopresti, Robert. *When Women Didn't Count: The Chronic Mismeasure and Marginalization of*

American Women in Federal Statistics. Denver: Praeger, 2017.

Meyer, Robinson. "How Gothic Architecture Took Over the American College Campus." *Atlantic*, September 11, 2013. https://www.theatlantic.com/education/archive/2013/09/how-gothic-architecture-took-over-the-american-college-campus/279287/September 11, 2013.

Mong, Albert V., Jr., *National Register of Historic Places Nomination: Philip G. Cochran Memorial United Methodist Church.* Washington, DC: Department of the Interior, National Park Service.

Mong, Albert V., Jr. and Dawson Anniversaries Corp. *Souvenir Book, 1872 — 1972 Centennial Anniversary, Borough of Dawson.* Dawson, PA: Dawson Anniversaries Corp. 1972. In the personal collection of the author.

Moore, Eva Perry. "Women in Collegiate Administration," *Association of Collegiate Alumnae Magazine,* 3, no. 14, (February 1907): 40-48.

Morning Herald (Uniontown, PA). "Call 11 Women for Jury Duty as Term Opens." December 6, 1921. Newspapers.com.

———. "Committees and Aides for Suffrage Tea at Dawson." July 27, 1915. Newspapers.com.

———. "Companies Dissolving." September 15,

1908. Newspapers.com.

———. "Congregation Given Church at Dawson." November 21, 1927. Newspapers.com.

———. "Dawson Woman, Aged 97, Dies." May 17, 1915. Newspapers.com.

———. "Dr. Anna Howard Shaw at Dawson Rally on July 29." July 17, 1915. Newspapers.com.

———. "Frick Coke Company Buys Juniata Coke Plant for $150,000, Possession Aug. 1." July 28, 1908. Newspapers.com.

———. "Sarah Cochran Dies at Family Home in Dawson." October 28, 1936. Newspapers.com.

———. "Mark Mordecai Cochran." November 30, 1936. Newspapers.com.

———. "Passing of Washington Run Railroad." March 14, 1931. Newspapers.com.

———. "8,000,000 Tons of Coal Mined in District 11." February 14, 1914. Newspapers.com.

Mount Union Times (PA). "Pennsylvania State Items." July 25, 1919. Newspapers.com.

Mulrooney, Margaret M. "A Legacy of Coal: The Coal Company Towns of Southwestern Pennsylvania." Historic American Buildings Survey/Historic American Engineering Record. Washington, DC: Department of the Interior, 1989. Google Books.

Neuman, Johanna. *Gilded Suffragists: The New York Socialites Who Fought for Women's Right to Vote.*

New York: Washington Mews Books, 2017.

Neumayr, George. "Pittsburgh Titan Henry Clay Frick Was the Gilded Age's Man of Steel." *Investor's Business Daily,* April 15, 2016. https://www.investors.com/news/management/leaders-and-success/pittsburgh-titan-henry-frick-was-the-gilded-ages-man-of-steel/

News (West Chester, PA). "At Rest in a Costly Casket." March 7, 1901, James Cochran Alumni File, University of Pennsylvania Archives.

Nickliss, Alexandra M. *Phoebe Apperson Hearst: A Life of Power and Politics.* Lincoln, NE: University of Nebraska Press, 2018.

Oakdale Leader (CA). "Stanford University." February 7, 1890. Newspapers.com.

O'Bryon, Mary Kate. "Beautiful Linden Hall's Influence for Votes for Women." *Pittsburgh Post-Gazette,* July 25, 1915. Newspapers.com.

Oliver H. Bair. Company advertisement. *Philadelphia Times.* March 28, 1900. Newspapers.com.

Pactor, Andrea. *A Sense of Place: A Short History of Women's Philanthropy in America.* Women's Philanthropy Institute at the Center on Philanthropy at Indiana University: March 2010. http://www.philansci.com/we2014/wp-content/uploads/2014/09/A-Sense-of-Place.A-short- history-of-Womens-Philanthropy-in-America.pdf.

Pendleton, Ellen F. "Conference of Women Trustees." *Journal of the Association of Collegiate Alumnae,* 10, no. 10 (June 1917): 700-701.

Pennsylvania Bureau of Mines. Report of the Department of Mines of Pennsylvania, 1870-1930. https://libraries.psu.edu/about/collections/pennsylvania-geology-resources/pennsylvania-annual-report-mines-year-1870-1979.

Pennsylvania Historical & Museum Commission. "1861-1945: Era of Industrial Ascendancy." http://www.phmc.state.pa.us/portal/communities/pa-history/1861-1945.html.

Pennsylvania State Normal School, Indiana, Pennsylvania. *Instano.* Indiana, PA: 1919.

Pennsylvania State Sabbath School Association. Conventions Records, No. 3, 1905-1912. Historical Society of Pennsylvania, collection 1839.

Philadelphia Inquirer. "Another Coke Company Chartered." February 14, 1891. Newspapers.com.

———. "Bair's New Funeral System." March 13, 1900. Newspapers.com.

———. "Church Leader Dies." September 6, 1925. Newspapers.com.

———. "Death of a Varsity Student." March 6, 1901. Newspapers.com.

———. "Three Enterprises Incorporated." August

2, 1893. Newspapers.com.

Philip G. Cochran Memorial Methodist Episcopal Church. *Philip G. Cochran Memorial Methodist Episcopal Church Dedication Services, November 20 to 27, 1927.* Dawson, PA: Philip G. Cochran Memorial Methodist Episcopal Church, 1927. Deposited with United Methodist Archives Center, Madison, New Jersey.

Philip G. Cochran Memorial Methodist Episcopal Church. *Program of Services in the Cochran Memorial Episcopal Church, Dawson, Pennsylvania, during the Semi-Annual Meeting of the Board of Bishops of the Methodist Episcopal Church, April 16th to 27th, 1916.* Dawson, PA: Philip G. Cochran Memorial Methodist Episcopal Church, 1916. Deposited with United Methodist Archives Center, Madison, New Jersey.

Philip G. Cochran Memorial United Methodist Church. *Philip G. Cochran Memorial United Methodist Church 75th Anniversary 1927-2007.* Dawson, PA: Philip G. Cochran Memorial United Methodist Church, 2007. In the personal collection of the author.

Pittsburgh Bulletin. "Art and Artists." October 28, 1905. Historic Pittsburgh.

Pittsburgh Daily Commercial. "List of Bills." May 23, 1874. Newspapers.com.

Pittsburgh Daily Post. "An Old Mine Closed." August 23, 1912. Newspapers.com.

———. "Church Dedication in Dawson." July 15, 1900. Newspapers.com.

———. "College Reborn by $400,000 Gift." May 6, 1912. Newspapers.com.

———. "Frick Coke Company to Repair Old Plant." July 30, 1908. Newspapers.com.

———. "James Cochran." March 6, 1901. Newspapers.com.

———. "Mrs. Rose Ann Herbert." May 18, 1915. Newspapers.com.

———. "Producing Their Own Coke." February 14, 1891. Newspapers.com.

———. "Suffrage Benefit." July 24, 1915. Newspapers.com.

———. "Suffrage Tea Hostess Fete at 'Linden Hall.'" July 30, 1915. Newspapers.com.

———. "W. Harry Brown Sells Large Coal Holdings to Pittsburgh Steel." March 20, 1919. Newspapers.com.

Pittsburgh Dispatch. "The Juniata Coke Works." February 16, 1891. Newspapers.com.

Pittsburgh History & Landmarks Foundation. "Allegheny College Preservation Plan." Meadville, PA: Allegheny College, 2007. https://www.phlf.org/wp-content/uploads/2009/08/Allegheny_College_Preservation_Plan.pdf.

Pittsburgh Post. "Open Fayette County Campaign." July 30, 1915. Newspapers.com.

Pittsburgh Post-Gazette. "Church Discipline Discussed." April 22, 1916. Newspapers.com.

———. "Dawson (Pa.) Woman Honored by American University; Is Ardent Suffragist." July 16, 1915. Newspapers.com.

———. "Dissolution Notice." September 18, 1919. Newspapers.com.

———. "Dramatic Soprano Returns to Dawson (Pa.) from Berlin." June 18, 1915. Newspapers.com.

———. "Methodist Episcopal Bishops to Meet in Dawson." April 15, 1916. Newspapers.com.

Pittsburgh Press. "Aiding Another Church." October 13, 1901. Newspapers.com.

———. "Echoes of the Fourth." July 7, 1908. Newspapers.com.

———. "Hill Top Activities." September 19, 1919. Newspapers.com.

———. "Lucien Smith Lost." April 16, 1912. Newspapers.com.

———. "Mrs. Cochran's Suffrage Tea." July 25, 1915. Newspapers.com.

———. "Taken by Death." November 1, 1936. Newspapers.com.

———. "To Dedicate Church." November 20, 1927. Newspapers.com.

———. Untitled obituary of James Cochran. November 27, 1894. Newspapers.com.

———. "Whole State to Be Canvassed by Suffragists." October 28, 1913. Newspapers.com.

———. "$4 Million Will Mailed South." November 6, 1936. Newspapers.com.

Post (Pittsburgh). "James Cochran." March 6, 1901. James Cochran Alumni File, University of Pennsylvania Archives.

Presbyterian Banner (Pittsburgh). "Educational." October 30, 1902. Google Books.

Press (Utica, NY). "Was Made in Utica." March 8, 1901, James Cochran Alumni File, University of Pennsylvania Archives.

Record (Philadelphia). "The Day of Fortunes in Caskets." March 14, 1901. James Cochran Alumni File, University of Pennsylvania Archives.

Reed, R. Sidney. "West Virginia Alpha — University of West Virginia." *Shield,* 30, no. 3: 245. Phi Kappa Psi Archive.

Richards, Samuel J. "A Forgotten Muhlenberg School: Trinity Hall in Washington, Pennsylvania." *Western Pennsylvania History: A Journal of Mid-Atlantic Studies,* 87, no. 2: 247-278.

Robins, Roger. "Vernacular American Landscape: Methodists, Camp Meetings, and Social

Respectability." *Religion and American Culture: A Journal of Interpretation,* 4, no. 2 (1994): 165-91. JSTOR.

Robbins, Richard. "Old Coal Kings." *TribLive.* January 2, 2005. http://triblive.com/x/pittsburghtrib/news/regional/s_288197.html.

Romanoff, Kathryn L. "Stirring Rally for Suffrage in Fayette." *Pittsburgh Post-Gazette.* July 30, 1915. Newspapers.com.

Sage, M. Olivia. "Opportunities and Responsibilities of Leisured Women." *North American Review,* 181 (1905): 712-721.

Sandor, John and Lu Donnelly. National Register of Historic Places, (Washington, DC: Department of the Interior, National Park Service, 1989.

San Francisco Chronicle. "Girls at Palo Alto." November 24, 1889. Newspapers.com.

Sharma, Ritu and James Keefe, "A Solution for a Struggling Global Economy: Gender Equality," *Forbes,* October 14, 2011. https://www.forbes.com/sites/forbeswomanfiles/2011/10/14/a-solution-for-a-struggling-global-economy-gender-equality.

Shaw, Anna Howard. Papers. Schlesinger Library on the History of Women in America, Radcliffe Institute for Advanced Study, Mary Earhart Dillon Collection. https://id.lib.harvard.edu/ead/c/sch01002c00050/catalog.

Shield. "The Grand Arch Council." June 1906, 550. Phi Kappa Psi Archive.

Skiff, Ella. "Summer Home Looks Like a Fairyland." *The Evening Republican* (Meadville, PA). June 1, 1909. Newspapers.com.

Skrabec, Jr., Quentin R. *H.J. Heinz: A Biography.* Jefferson, NC: McFarland, 2009.

Smeltzer, Wallace Guy. *Methodism in Western Pennsylvania, 1784-1968.* Little Valley, NY: Straight Publishing, 1969.

Smeltzer, Wallace Guy. *Origins and Early Development of Methodism in Western Pennsylvania: Preaching Places in the Original Redstone Circuit of the Methodist Episcopal Church, 1786-1787.* Denver: Eastwood Printing Company, 1977. Historic Pittsburgh.

Smith, Edward Ashton. *Allegheny — A Century of Education, 1815 — 1915.* Meadville, PA: Allegheny College History, 1916.

Smith, Helene and George Swetnam. *A Guidebook to Historic Western Pennsylvania, 2nd ed.* Pittsburgh: University of Pittsburgh Press, 1991.

Snyder, Margaret. "A Noted Woman Philanthropist." *Pittsburgh Daily Post,* July 19, 1908. Newspapers.com.

———. "The Lady Bountiful of Beechwood Boulevard." *The Pittsburgh Press.* August 2, 1908. Newspapers.com.

St. Louis Post-Dispatch. "Lost One Husband, Gained New One, in Titanic Disaster." November 8, 1914. Newspapers.com.

Staff. "Happy 80th Gloria Steinem: 8 of Her Funniest Truisms." *Time,* March 25, 2014. https://time.com/36046/gloria-steinem-8-funny-quotes-80-birthday/.

Stanton, Elizabeth Cady. *"The Pleasures of Age," Elizabeth Cady Stanton Papers.* Library of Congress. https://www.loc.gov/item/mss412100094/.

Stanton, Elizabeth Cady et al. Declaration of Sentiments. https://www.nps.gov/wori/learn/historyculture/declaration-of-sentiments.htm.

Star-Gazette (Elmira, NY). "Bishops Will Meet Private Residence." November 6, 1915. Newspapers.com.

Sutton, Judy. "Suffrage: The Road to the Vote for American Women." Lecture presented via Zoom at the McKeesport Heritage Center in partnership with the Heinz History Center, McKeesport, PA, June 18, 2020.

Sylvia Sachs. "Steelworkers' Mansion Quite a Site." *Pittsburgh Post-Gazette.* July 6, 1980.

Tarbell, Ida M. *All In the Day's Work: An Autobiography.* New York: MacMillan, 1939. Archive.org.

Telegraph (Philadelphia). Untitled obituary of

James Cochran. March 6, 1901. James Cochran
 Alumni File, University of Pennsylvania
 Archives.

Thomas, M. Carey. "Joint Conference of Trustees,
 Deans and Professors." *Journal of the Association
 of Collegiate Alumnae,* 10, no. 10 (June 1917):
 701-702.

"Town of Star Junction, State Route 51, Star
 Junction, Fayette County, PA." Survey. Historic
 American Engineering Record, U.S. Department
 of the Interior, 1988. *https://www.loc.gov/pictures/
 item/pa3046/.*

University of Pennsylvania. *A Record of the Class
 of Nineteen Hundred.* Philadelphia, PA: 1900.
 University of Pennsylvania Archives & Records
 Center. *https://archives.upenn.edu/digitized-re-
 sources/docs-pubs/the-record/record-1900.*

Wagner, Sally Roesch, ed. *The Women's Suffrage
 Movement.* New York: Penguin Books, 2019.

Weekly Courier (Connellsville, PA). "An Enjoyable
 Trip." December 13, 1895. Newspapers.com.

———. "Back from Europe." September 1, 1905.
 Newspapers.com.

———. "Coke Trade Nestor Dead." November 29,
 1894. Newspapers.com.

———. "Dawson." October 30, 1891. Newspapers.
 com.

———. "Dawson Doings." December 7, 1894.

Newspapers.com.

———. "In P.G. Cochran's Memory." July 20, 1900. Newspapers.com.

———. "New Railroads in Fayette." November 22, 1895. Newspapers.com.

———. "Old Officers Re-Elected." January 18, 1901. Newspapers.com.

———. "Sistine Madonna Unveiled at Dawson." December 30, 1905. Newspapers.com.

———. "The Connellsville Coke Regions: Their Past, Present, and Future." May 1914. https://historicpittsburgh.org/islandora/object/pitt:31735062208412.

Western Pennsylvania Annual Conference of the United Methodist Church. *Official Journal and Yearbook: Official Minutes of the Pittsburgh Annual Conference of the Methodist Episcopal Church, held at South Avenue Church, Wilkinsburg, PA, September 28 — October 3, 1937.*

Williams, Tate. "Generosity and Impact Aren't Enough. Let's Judge Philanthropy on How Well It Shifts Power." *Inside Philanthropy.* September 6, 2019. https://www.insidephilanthropy.com/home/2019/9/6/why-impact-and-generosity-arent-enoughtoward-judging-philanthropy-on-how-well-it-shifts-power.

Woodrum, David L. *In the Bond: 100 Years within*

West Virginia Alpha. Self-published, 2006.

1850 United States Census. Dunbar Township, Fayette County, Pennsylvania. Washington, DC: National Archives and Records Administration, n.d. FamilySearch.org.

1860 United States Census. Dunbar Township, Fayette County, Pennsylvania. Washington, DC: National Archives and Records Administration, n.d. FamilySearch.org.

1860 U.S. Nonpopulation Census Schedule, Agricultural. Washington, DC: National Archives and Records Administration, Central Plains Region, 1970. FamilySearch.org.

1870 United States Census. Tyrone Township, Fayette County, Pennsylvania. Washington, DC: National Archives and Records Administration, n.d. FamilySearch.org.

1870 U.S. Nonpopulation Census Schedule, Agricultural. Washington, DC: National Archives and Records Administration, Central Plains Region, 1970. FamilySearch.org.

1880 United States Census. Upper Tyrone Township, Fayette County, Pennsylvania. Washington, DC: National Archives and Records Administration, n.d. FamilySearch.org.

1900 United States Census. Dawson Borough, Fayette County, Pennsylvania. Washington, DC: National Archives and Records Administration,

n.d. FamilySearch.org.

1910 United States Census. Dawson Borough, Fayette County, Pennsylvania. Washington, DC: National Archives and Records Administration, n.d. FamilySearch.org.

1910 United States Census. Pittsburgh Ward 14, Allegheny County, Pennsylvania. Washington, DC: National Archives and Records Administration, n.d. FamilySearch.org.

1.0 Please tell us briefly about se

1.A. What were the family connections that drew you to this story?

1. What was the most challenging aspect of writing Sarah Cochran's biography?

2. What did you learn that surprised you the most?

3. How did Cochran's life change after the early deaths of her husband & son?

4. How is this book a story about how women could use philanthropy as a form of influence & activism?

5. Tell us how Cochran championed woman suffrage.

6. By studying Cochran's whole life, what did you learn about aging?

7. What do you most want readers to take away from Cochran's story?

Discussion

Questions

8. What part of Cochran's life history would you have liked to learn more about?

9. Do you have any advice for those who want to learn more about their own family's histories?

1. How do you think Sarah's engagement with the world, especially her philanthropic activity, might have been different if Philip and James had not passed away so early in life?

10. How important is the particular region of southwestern PA to this story?

2. After her husband's and son's deaths, Sarah's life was shaped by her decision to fully participate in the world and help others. How have you made a choice to participate more fully in the world when you could have stayed in your comfort zone?

11. How was Cochran involved in promoting girls' education?

3. Gender made Sarah rather unique in her industry. When she could have blended in by not drawing attention to her gender, she publicly championed women's suffrage. Have you ever been the only, or one of the few, representatives of a particular group in a leadership position?

12. What is the significance of Cochran's role as a builder? Tell us how Cochran championed women's suffrage?

227

Did you emphasize what made you unique or try to blend in under different circumstances, and why? Did either path have a particular outcome?

4. Sixty Italian stonemasons worked on Linden Hall at St. James Park, and Sarah was said to have sponsored those who applied for American citizenship. In more general terms, what could it mean to be someone's sponsor? How can you be an effective sponsor to someone who is from a background that's different from yours?

5. Sarah was in her early forties when she lost her husband and son, and she remained active in her own right well into her seventies. What expectations do you think exist around a person's age and their ability to do new things, either personally or professionally? What challenges and opportunities do age and experience offer?

6. For better or worse, Sarah's life took a number of unexpected directions. Have you ever had to deal with an unexpected change to your life's path? How did you manage this? Did it ever mean having to address someone else's decisions or ambitions?

7. Outside of a particular geographic region, Sarah's story was virtually unknown. When you think about historic figures, why do you

think some are widely known and others aren't? How can individuals and communities tell their stories?

8. One of the challenges of writing about a historic figure is deciding what topics to cover in detail. As more is written about that person, new information and perspectives can come to light. What other information or perspectives would you like to learn about Sarah?

9. Sarah's story took place in a very particular place and time and involved specific industries and organizations. What universal elements can you find in her life experiences?

10. In the epilogue, the author expresses gratitude for having a meaningful place to share with her daughter. What makes places so important in keeping stories and history alive?

11. Throughout the book, there are different results when someone finds value in things or people. For example, Little Jim Cochran became wealthy when someone saw value in his Connellsville coke, and by investing in people and organizations she valued, Sarah Cochran expanded her profile. Have you ever seen value in something that others did not? What was the outcome?

Made in the USA
Middletown, DE
21 January 2022